The Art of the
TATTOO

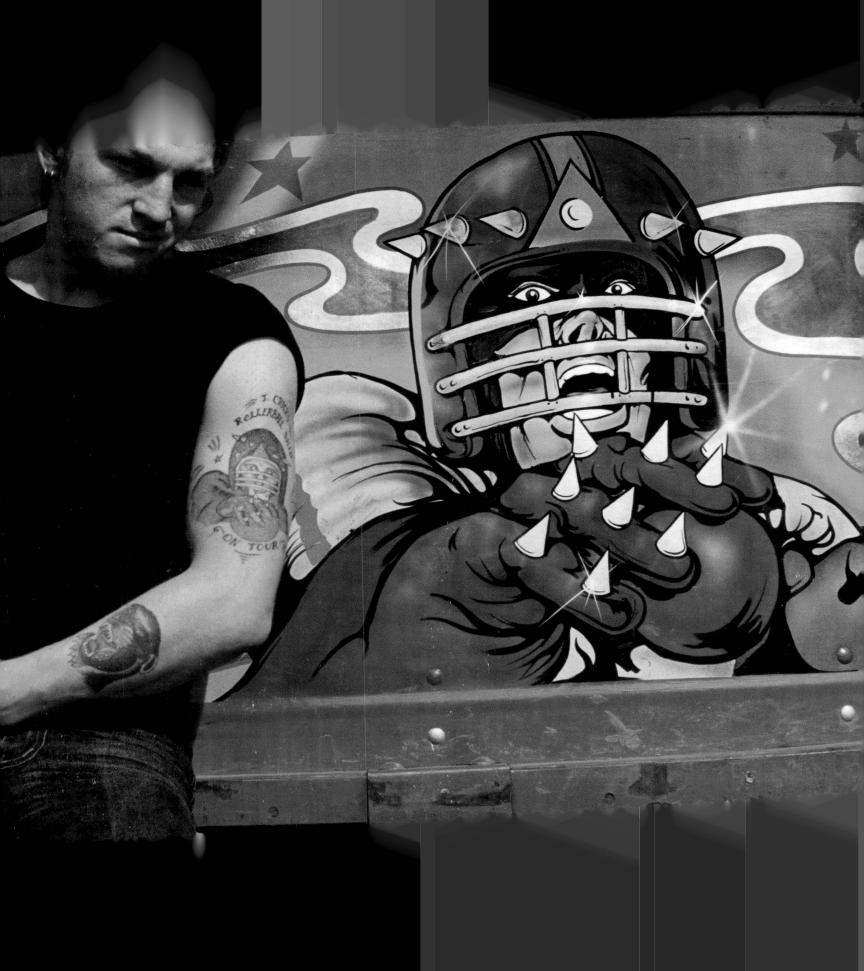

The Art of the
TATTOO

BY HENRY FERGUSON AND LYNN PROCTER,
EDITORS OF **body art** MAGAZINE

COURAGE
B O O K S
AN IMPRINT OF RUNNING PRESS
PHILADELPHIA • LONDON

CLB 5015

© 1998 CLB International,
a division of Quadrillion Publishing Limited,
Godalming, Surrey, UK

Printed and bound in Spain

9 8 7 6 5 4 3 2 1
Digit on the right indicates the number of this printing
Library of Congress Cataloging-in-Publication Number 97-68295

ISBN 0-7624-0273-3

credits
Commissioning editor: Will Steeds
Editor: Roz Cocks
Picture research: Henry Ferguson and Lynn Procter, **body art** magazine
Design: Fiona Roberts, The Design Revolution, Brighton, UK
Production: Neil Randles, Ruth Arthur, Karen Staff
Color reproduction: Global Colour Separation, Malaysia

Published by Courage Books, an imprint of
Running Press Book Publishers
125 South Twenty-Second Street
Philadelphia, Pennsylvania 19103-4399

dedication

Popular books and magazines containing photographs of tattooed people are a comparatively modern
phenomenon. When we started **body art** magazine in 1987, the only generally available magazines for tattoo
enthusiasts were aimed at bikers, and very few shops stocked the handful of books on tattooing by Don Ed Hardy and
photographer Chris Wroblewski. Tattoo fans have, however, always been fascinated by photographs of tattoos.

This was recognized by English tattooist Bill Skuse back in the early 1970s, and he found a ready market
for his personal collection of tattoo photographs, some of which were sold and some exchanged with other
tattooists and tattoo fans around the world. Images were copied, distributed, and copied again. Many of the
older photographs in this book come from the Skuse collection, and show some of the ordinary – and
extraordinary – men and women who have chosen to be tattooed over the years.

This book is dedicated to all of those tattoo fans and tattoo artists who made it possible – by getting
tattooed, by doing the tattooing, by allowing themselves to be photographed, and by allowing others to
share those images. Special thanks to Bill Skuse and Don Ed Hardy (the preeminent American collector and
publisher of tattoo art) who had the forethought, imagination, and intelligence to realize that if they did not collect
and, in their very different ways, disseminate these images of tattoo art, then this art might be lost forever.

contents

foreword

6

I first walked into a tattoo studio in the early 1970s – a boy in a man's world, a world full of color, magic, and mystery. From the resulting first needle-prick into my right forearm as a 14-year-old, I was hooked. My first true love was a green-and-blue swallow with a flower and two scrolls – one inscribed with my name, the other dedicated to Mum and Dad: my mother because she gave me life; my father because he gave me my passion. For it was my interest in my father's tattoos that spurred me to get on the bus that Saturday morning to travel to Rob Robinson's tattoo surgery in nearby New Malden, England.

It was not long before my passion grew into an obsession; an obsession that has since driven me to travel the world, meet some of the greatest names in tattoo history, and live the kind of life that many people would give their right arms for. I am now the curator of the British Tattoo History Museum in Oxford and vice president of the Tattoo Club of Great Britain. I have judged at some of the world's leading tattoo conventions, including shows in the United States, Australia, New Zealand, Sweden, Germany, Belgium, and all over Britain and Northern Ireland.

Tattooing, even in my short time, has been through many changes, not least the change in public opinion toward it. No longer is tattooing seen as the domain of undesirable elements of society – indeed, it is now given frequent, and favorable, exposure in the media. Many gifted artists have entered the profession, and much of their work would not look out of place in an art gallery (significantly, female tattoo artists are responsible for doing some of the finest work around today).

January, 1976 saw the world's first tattoo convention in Houston, Texas (although before this there were many tattooing parties, such as Les Skuse's parties in the early 1950s for the Bristol Tattoo Club in England). Today, conventions in all parts of the world draw hundreds of thousands of people every year.

Studios have become more aware of hygienic requirements, artwork has improved, machines have become more refined, and, in general, there seems to be a healthier attitude on the part of the general public.

But what has not changed is people's enthusiasm to get tattooed, and, hopefully, this book will not only tell you all you need to know about the history of tattooing but will also give you a better understanding of one of the oldest artforms known to man.

I have found *The Art of the Tattoo* to be one of the most enjoyable and comprehensive studies of tattooing to date and it will, I am sure, be a welcome addition to libraries throughout the world and, as a book, become as unique as the art of tattooing itself.

PAUL SAYCE

Tattoo writer, expert, and fan

Photograph on page 2: Fairground worker photographed at Jaywick, England, in the late 1970s.

DICK PARSONS

introduction

In the ten years since we published the very first issue of body art magazine, the world of tattooing has changed almost beyond recognition. Then, we saw new tattoo artists producing exciting work, and we guessed that the general public was ready to embrace tattooing (and body piercing) but, in the mid 1980s, it was very hard to persuade the magazine distributors, book stores, and banks that tattooing could – and would – become popular.

But the world can change a lot in ten years, and the revolution in tattooing has been astonishing: tattooing has become immensely popular. It has been accepted by people who would never have dreamed of getting tattooed ten years ago. It has become fashionable. Thousands of new tattoo artists have emerged. New styles of tattooing and ideas about what tattooing is, and can be, have emerged. And this explosion of interest and talent has taken the art of tattoo to new heights of excellence.

Tattooing is an enormous subject, and it would be hard to include within one book all of the many cultures in which tattooing is or has been practiced, just as it would be impossible to include examples of the artistry of every one of the thousands of excellent tattooists practicing their craft in every country from the United States to Australia. But what we have aimed to do in this book is provide background information about tattooing's fascinating past – both in the West and in other cultures, and to explore the art of contemporary tattooing around the world using 200 wonderful photographs of some of the very best examples of tattooing ever produced.

For us, tattooing is fascinating, compelling, and inspiring. It combines the beauty of traditional cultures with the individuality of the West. It allows us to transform the bodies that we were given into something we choose to be. Tattooing is a uniquely difficult art form because it must exist on a constantly changing, stretching, moving, living canvas. In the final analysis, a tattoo is the ultimate adornment.

7

**HENRY FERGUSON AND
LYNN PROCTER**

**Editor and Deputy Editor
of body art magazine**

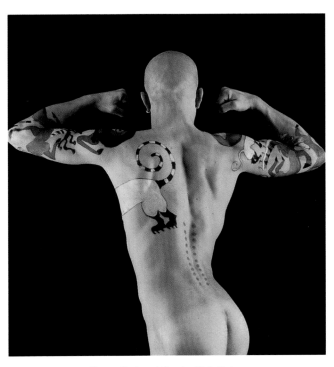

Above: Body painting by Chris Going.
(*See long caption on page 11.*)

HENRY FERGUSON

"We are the only creature on this planet which chooses and manipulates its own appearance." Ted Polhemus (1)

section 1: # the history of tattooing

Our desire to decorate ourselves is one of the most basic ways in which humankind differs from other animals. Tattooing – whether for magical purposes, tribal affiliation, a sign of status, sexual allure, or simply as beautification – is one of the oldest and most universal expressions of that desire.

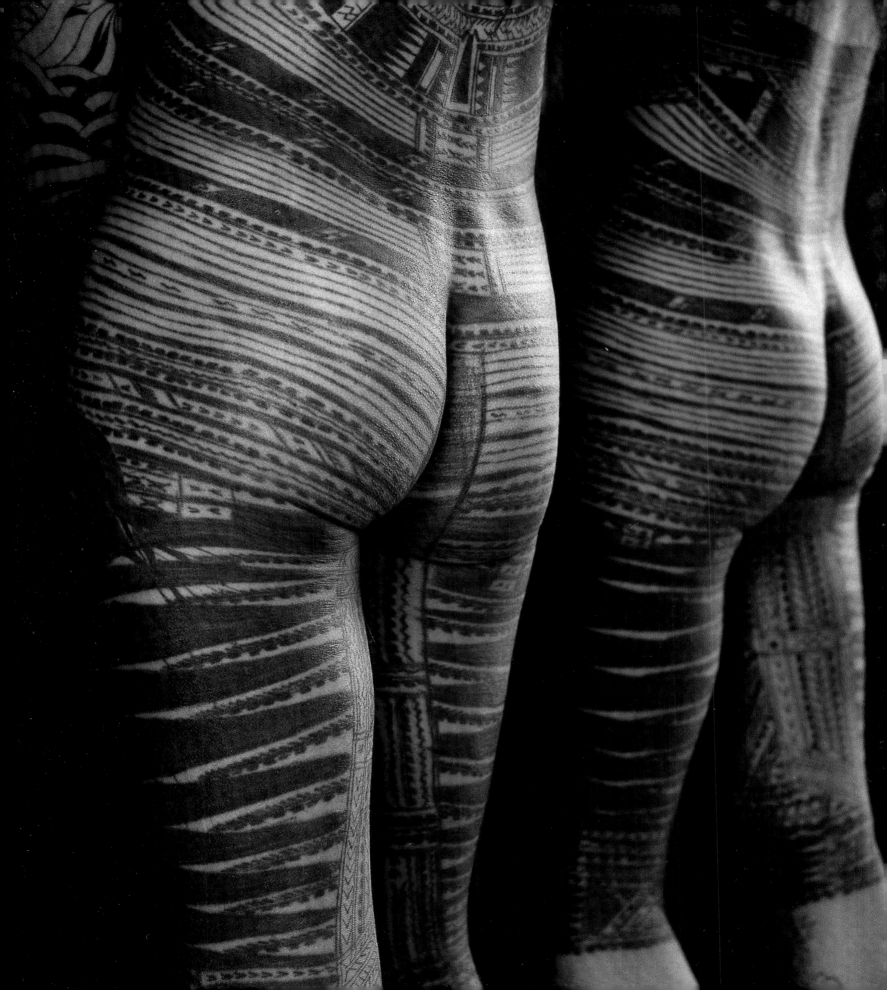

early
history

There are many reasons for believing that tattooing was one of the very first arts practiced by mankind.

It is a basic tenet of social anthropology that the more widespread a practice, the older it is. Tattooing is practiced from Alaska to Japan, from Siberia to Polynesia, from India to North Africa. Also, many different techniques are used around the world to introduce pigment beneath the skin. This suggests that, instead of starting in one place and then spreading, as the fashion caught on across the globe, tattooing is a reflection of the basic human desire/need to decorate the body, and that the many different techniques and styles arose as different peoples in different situations spontaneously and independently sought their own individual ways of expressing this need.

It is therefore reasonable to suppose that tattooing has been practiced since the point in prehistoric times when our simian ancestors first began to develop self-awareness, form themselves into social units, and use tools. Many scholars believe that tattoos are represented in the marks shown on rock carvings, sculptures, paintings, and other images of the human body created by many ancient civilizations worldwide. But without any evidence of actual preserved tattoos, we cannot be sure whether these marks represent body painting, scarification, or simply artistic license.

The problem is that flesh decomposes very easily, and it is only under very unusual circumstances that the skin of ancient corpses is preserved well enough for us to be able to determine whether or not it was tattooed. Recent finds (combined with advances in the science of the preservation of ancient bodies) have, however, supported the contention that many of our ancestors chose to decorate their bodies with tattoos.

The oldest tattoos so far discovered were those found on the frozen 5300-year-old body of a man that was unearthed in the Italian Alps, close to the border with Austria. This iceman, who was estimated to be some 45 years old when he died, had 57 tattoos in various places on his body. For example, on his right lower leg he had three lines on the ankle, with a further three lines a little higher up, and more lines marking the left side of his back. Research has revealed that all of these tattoos were placed close to joints that had suffered arthritic damage. It is therefore presumed that the tattoos were done in an attempt to alleviate the arthritic pain that he suffered. The iceman's body had not been buried with any ceremony; instead, it is thought that he was a comparatively ordinary member of his society who died when he was caught by bad weather high in the mountains, and who became frozen solid in the ice until unusual weather conditions revealed him 5300 years later. It therefore seems reasonable to presume that the use of tattoos as treatment for physical ills was common practice, at least among his people, at that time.

It was a most unusual accident that allowed the iceman's tattoos to be preserved for over 5000 years. The next oldest evidence of tattooing is from Egypt some 4000 years ago, and its discovery was only made possible because the body in question was ceremonially embalmed.

Although it is believed that markings that have been found on clay female figures from the fourth millennium B.C. represent tattoos, the practice of embalming was not fully developed until about 2600 B.C., so it is currently impossible to tell from finds dating from before this whether or not women at that time really were tattooed:

Above: A Caroline Islander.
(The Caroline Islands are a part of
Micronesia to the north of New Guinea
and east of the Philippines.)

BIBLIOGRAPHISCHES INSTITUT, LEIPZIG

10

Above: Body painting by Chris Going. HENRY FERGUSON

One of the most exciting examples of tattooing in ancient times discovered so far was found in 1947 on the body of a fifth-century B.C. chieftain or warrior excavated from a burial mound at Pazyryk in the Eastern Altai mountains of Southern Siberia.

Stone cairns erected above these burial mounds had kept the bodies and artifacts beneath them permanently frozen, preserving intact all organic materials which included leather, wood, felt, and textiles:

Finds from the graves show the area had far-flung links with China, Persia, and the Black Sea, and the people shared with the Scythians of the latter region a distinctive artistic style. The burial rituals of the Scythians, as recorded by the Greek historian Herodotus, are similar to those in the Altai – as was the practice of tattooing high status individuals. (3)

11

The dead man's shoulders, chest, back, and probably both of his legs were extensively tattooed with designs of fish and animals, including felines, beaked deer, and mountain rams. The original monochrome tattoos were performed by pricking the skin to introduce a coloring agent such as lamp black, but the colors used in this painted recreation of the Pazyryk tattoos (*see also photograph on page 7*) would have been available to those people, and reflect the colors used at that time to decorate other objects in the same style.

"The practice of skin ornamentation is certainly as widespread and as ancient as Man himself. It may well have been one of his first conscious acts, which distinguished him from the rest of the animal kingdom." Christopher Gotch (2)

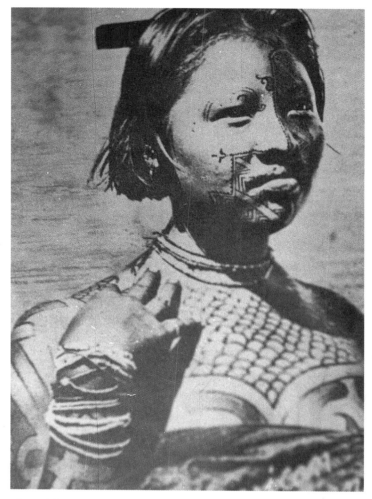

Above: A Parana Indian woman, showing extensive tattooing on her chest and shoulders as well as on her chin, cheeks, nose, and forehead.

THE SKUSE COLLECTION

During the course of the [Egyptian] Middle Kingdom, however, the first incontrovertible evidence of tattoo enters the record. That evidence takes the form of actual tattoo preserved on the mummy of a woman named Amunet, who served as a priestess of the goddess Hathor at Thebes during Dynasty XI, about 2160-1994 Her mummy was in an excellent state of preservation. Her tattoos comprise a series of abstract patterns of individual dots or dashes randomly placed upon the body with apparent disregard for formal zoning An elliptical pattern of dots and dashes is tattooed on the lower abdomen beneath the navel. Parallel lines of the same pattern are found on the thighs and arms. A second mummy, identified as that of a female dancer who lived at approximately the same time, is decorated with dots composed into diamond-shaped patterns on the upper arms and chest The priestess Amunet and the [decorated] figurines in question are all associated with Hathor, the most

lascivious of all Egyptian goddesses Consequently the tattoos of this group of figurines and of the mummy of Amunet have an undeniably carnal overtone. Apparently for reasons of prudery, earlier commentators held ancient Egyptian tattoo in low esteem and had little regard for those who were so decorated. **(4)**

Many scholars believe that tattooing was introduced to Egypt from neighboring Nubia. A tattooed female mummy from about 2000 B.C. (roughly contemporary with Amunet), with tattoos very similar to those on the Egyptian mummies, was discovered at the Nubian village of Kubban. This style of tattooing continued in Nubia for almost 2000 years. Examples of tattoos in precisely the same configurations have been found on adult and adolescent female mummies dating from the fourth century B.C., and on a painting of a Nubian tumbler from circa 1000 B.C.

Tattooing also continued in Egypt itself, but the abstract dot-and-dash patterns gave way to images of the god Bes, similar to that used as a protective talisman on household goods. Bes was also associated with revelry, sexual cavorting, and childbirth, and it was because of this sexual association that his image was tattooed on the thighs of female dancers and musicians of the New Kingdom (1550 B.C. onward).

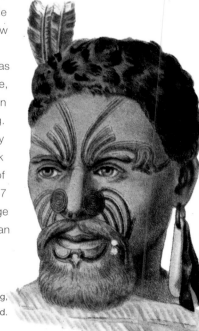

Although none of them date from as far back as those described above, tattoos have also been discovered on other bodies preserved by freezing. The tattooed body of a fifth-century B.C. chieftain or warrior at Pazyryk in the Eastern Altai mountains of Southern Siberia was found in 1947 (see the photograph caption on page 11), and the tattooed body of an

Right: Facial *moko* on a Maori king, New Zealand.

BIBLIOGRAPHISCHES INSTITUT, LEIPZIG

"During the course of the New Kingdom the ancient Egyptian tattoo enjoyed the height of its popularity and diversity. Reserved exclusively for women, the tattoo of the Egyptian New Kingdom could be imbued with either religious or secular overtones. This duality of function, which characterizes the Egyptian tattoo, may serve as a reminder that even today, in such a pluralistic society as ours, the tattoo continues to serve diverse needs and interests." Robert S. Bianchi [5]

embalmed and ceremonially buried female, commonly referred to as the "Ice Maiden," was found much more recently in the same region. The Ice Maiden was an exceptionally tall young woman of around 25 years old, who had held an important position in her society, very probably as a storyteller. As with the male, she too was covered in beautiful tattoos of animal imagery that included goats, wolves, felines and, most important of all, deer. The tattoos had been drawn when she was young and had been pricked into her skin with soot and bone needles. We cannot be sure why she was tattooed, but it seems likely that these images had some kind of mystical significance; clearly, they had not been drawn on the young woman solely for aesthetic reasons.

Piecing together a coherent picture of tattooing in the distant past is extremely difficult. All we can really do is note the occasional mentions of tattooing in ancient texts.

In Ancient Greece, to take one example, tattooing seems generally to have been regarded as a way of marking slaves and criminals, although some of the commentators writing at that time describe how, in some cities, the young men from wealthy families got themselves tattooed, that tattooing in other regions was a sign of nobility or of bravery, and that the women of Thrace were tattooed.

Tattooing certainly must have been practiced in the Middle East – if not, there would have been no need for the specific prohibitions of tattooing which appear in both the Koran, the holy book of the Muslims, and in the Mosaic code of the Jews.

Most of the Iron Age tribes that lived in Europe – such as the Iberians, Britons, Gauls, Goths, Teutons, Picts, and Scots – were tattooed. Herod of Antioch in the third century A.D. described the Britons thus: **" . . . [they] incise on their bodies colored pictures of animals, of which they are very proud" According to St. Isidore of Seville "the Scots derive their name in their own language from their painted bodies, because these are marked with various designs by being pricked with iron needles with ink on them and the Picts are also thus named because of the absurd marks produced on their bodies by craftsmen with tiny pinpricks and juice extracted from their local grasses." (6)**

The Roman people, whose conquering Empire spread throughout these tribal lands, were not originally practitioners of tattooing, but some Romans clearly adopted the practice later, for it was banned by the Emperor Constantine when he made Christianity the Empire's official religion in A.D. 325. Constantine's presumption that tattooing was an uncivilized, barbaric, and un-Christian practice seems to have persisted, in one form or another, in the West up until the present day.

The survival of tattooing down through the ages, despite all of the prohibitions and negative associations, is a testament to the power of the human urge to be tattooed: to have our bodies marked as we choose, and in a way which no one else can take away from us, just as our ancestors did thousands of years ago.

13

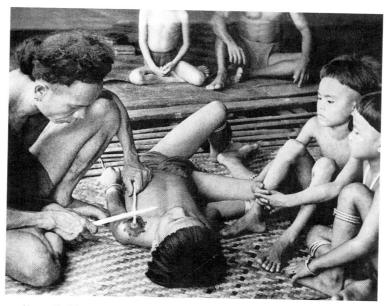

Above: Traditional tattooing among the Ibans of Borneo around 1930. Generally a design carved into a wood block is stamped onto the skin. This design is then pricked into the skin using a needle tied to a stick which is then tapped with a hammer-like wooden striker. The pigment is made from soot or lampblack.

THE SKUSE COLLECTION

ethnographic
tattooing

I t is only comparatively recently that the majority of Westerners have been able to perceive ethnographic tattooing – tattooing in other societies – as anything other than primitive, pagan, disfiguring attempts to deface God's handiwork, but we are at last coming to appreciate the beauty of this traditional art form.

Tattooing is spread widely throughout the world, with examples occurring in most regions except in those parts of Africa where the people's skin is so dark as to make the introduction of pigment pointless. In this situation, scarification is used instead of tattooing as a medium for permanently decorating the body, using three-dimensional patterns of raised scar tissue instead of two-dimensional designs in color.

Japan is probably the country best known for its traditional tattoos, but the Japanese style of tattooing that we know today is both comparatively recent, essentially originating in the early 1800s (*see pages 30-31*), and generally socially unacceptable:

Most Japanese – those at any rate who will admit to there being any tattooing at all in their country – will insist that it is only the gangsters, the yakuza, and their underlings who sport such decorations, though the most cursory investigation reveals that it is still the craftsmen and the laborers who form the major part of the tattoo master's clientele. (7)

Although there are parallels to be drawn between Japanese and Western attitudes toward tattooing,

tattooing is regarded favorably within most of the societies in which it is practiced. For example, among the Maori of New Zealand it has always been considered highly desirable, and is associated with the most important members of the society. Archeological evidence of bone tattooing chisels show that Maori tattooing, like that in Polynesia as a whole, dates from the earliest days of the culture and is at least 2000 years old. Two different types of tattooing are practiced by the Maori: regular tattooing on the body, which is carried out with needle-combs, as it is elsewhere in Oceania, and *moko,* the form of facial tattooing in which lines are carved into the skin of the face using chisels.

Maori tattooists were male, and it was usual for males to be decorated in the area between the waist and knees, and women on the lips and chin. Exceptions, however, were not unusual, and there are examples of both sexes being extensively tattooed elsewhere on the body, including on the tongue and genitals. *Moko* designs include not only the curves and spirals that are most commonly recorded, but also straight-line designs. Each design was so personal to the individual who wore it that some chiefs used a drawing of their *moko* as a signature on documents.

Male *moko* ceased during the second half of the nineteenth century, but female *moko* grew in popularity during the same period. *Moko* has strong associations with high status, but it is also known that captives in the intertribal wars of the 1820s were

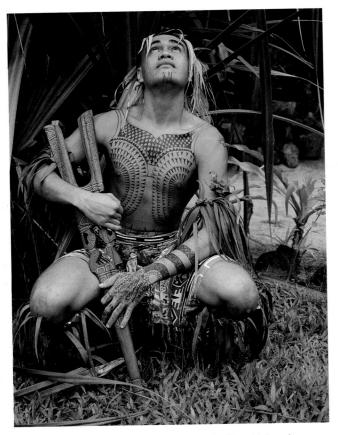

Above: Teina Toromona's contemporary traditional tattoos by Tavita, Tiki Village, Tahiti, French Polynesia.

CHRIS WROBLEWSKI/SKIN SHOWS

14

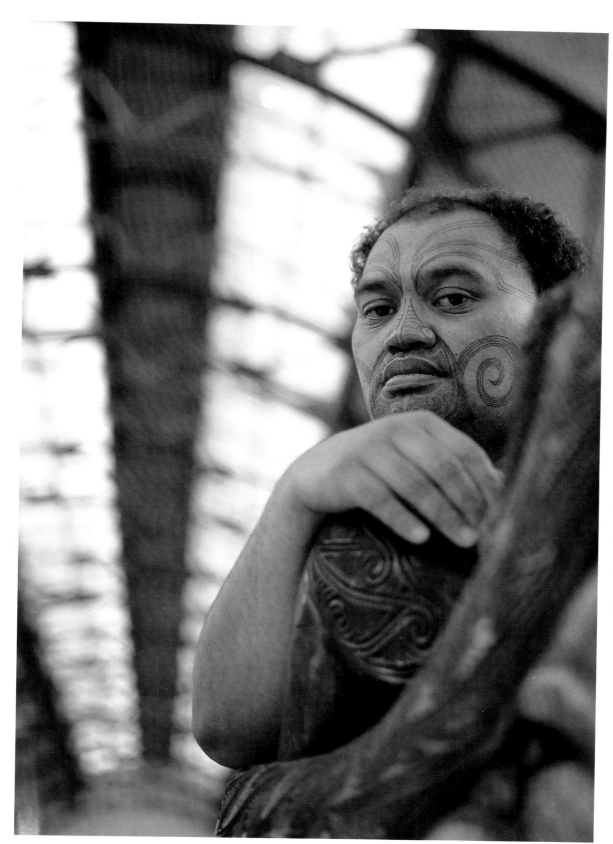

Left: Facial *moko* tattooed on Herbie by Graham Cavanagh of New Zealand.

JAN SEEGER

"Moko *provided natural camouflage in times of war, and gave the warrior the confidence of an intimidating, even awesome, appearance. It also displayed one's capacity for pain and endurance, and it enhanced the carrier's erotic appeal quite considerably."*
Ngahuia Te Awekotuku (8)

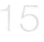

15

16

given extensive *moko* in order to increase the value of their heads when eventually sold to Europeans. We cannot be sure of the "meaning" of *moko*, but it has always been a symbol of Maori identity. Today, now that young Maori are once again choosing to receive *moko* as part of their exploration of their culture, that symbolism is as strong as it ever was.

Throughout most of Polynesia tattooing was widespread, including on the Marquesas and Solomon Islands, and in Tahiti, Samoa, and Hawaii. But the arrival of Christianity was one of many blows to these traditional cultures and very little tattooing survived into the twentieth century, other than that recorded in the beautiful illustrations of explorers and ships' artists. In many of these islands too, young people are now working very hard to rediscover what has been lost. Their adoption of traditional tattooing styles is one way in which they can reconnect with the past and reaffirm their allegiance to, and identification with, their indigenous culture as opposed to modern Western culture.

On the Hawaiian Islands both men and women could be tattooed on almost every part of the body, including – extremely painfully – on the tongue:

One of the primary functions of male tattoo was protection in battle the tattooing process was carried out in conjunction with the chanting of sacred prayers that protected the warrior, especially those of high rank. The process of puncturing the skin during the recitation of a prayer could capture the prayer and envelop the owner with permanent sacred protection.

Tattoo was also a genealogical commemorative device, especially of the

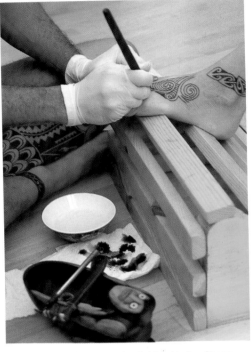

Above: Tom Pico tattooing Patricia Lindley Shema on Volcano Island, Hawaii.

CHRIS WROBLEWSKI/SKIN SHOWS

"According to Polynesian mythology, humans learned tattooing from the gods. Such a decoration was therefore applied in a ritual and ceremonial context by particularly revered masters."

Dr Hanns Peter [9]

death of important related persons of high rank. It was widespread Polynesian practice to show unbounded grief at the death of a chief. In Tonga, for example, finger joints were cut off. In Hawaii the tongue was tattooed . . . This convention evolved into the nineteenth-century practice of tattooing a chief's name and date of death on one's arm Tattoo soon became primarily decorative; goats became a fashionable exotic motif, and ships' artists were pressed into service to provide a variety of introduced designs including hunting horns for the posteriors of female chiefs. (10)

We now associate Hawaii with a specific style of straight-line geometrical design decorated with checkerboard patterns and rows of triangles, but when European explorers arrived they also found images of men and animals. They were surprised to discover many asymmetrical designs, and mistakenly presumed these were unfinished:

Asymmetry seems to have been important where tattoo was primarily a protective device. Symmetry seems to have been introduced when tattoo became primarily decorative. (11)

Drawings by Europeans from the late-eighteenth and early-nineteenth centuries show some very beautiful examples of tattoo work, but it seems that, by then, tattooing in Hawaii was already in decline, and by the mid-nineteenth century it had nearly died out completely.

The Ibans or Sea Dayaks, who live in the part of Borneo that is now in Malaysia, also have a long history of tattooing, and here too it is difficult to establish the "meaning" of their tattoos. There appears to be some connection with fighting skills – certain neck tattoos attest to the

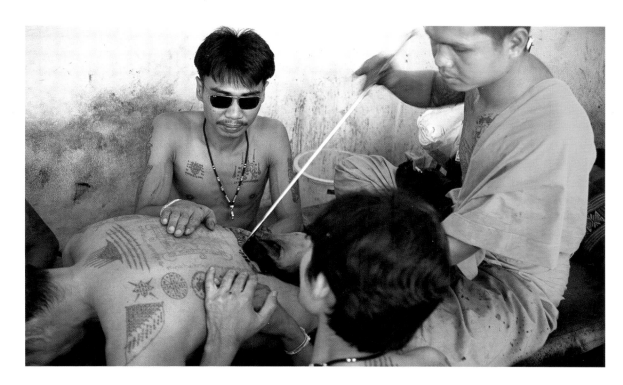

manliness of the wearer, and some hand tattoos were restricted only to those men who had taken the head of an enemy – but women are also tattooed.

Different tribal groups choose to be tattooed on various different parts of the body, including the torso, legs, feet, arms, and hands. Designs at first appear to be abstract, but are in fact highly stylized versions of dogs, flowers, birds, boats, the moon, and even the human face. Unlike in many parts of the world, tattooing is still practiced by some members of the ethnic population (the Ibans), but this continuing tradition may be the result of their being cut off from the rest of the world.

Elsewhere in the world, small pockets of traditional tattooing still continue. For example, tattooing has been practiced for generations by many of the traditional "tribal" peoples of South America, North Africa, the Indian subcontinent, Burma, and Nepal. It is widespread among the Newar men and women of Bhaktapur in Nepal, where designs include Hindu gods and goddesses, birds, flowers, and lattice-work:
When one woman was asked why she wears tattoos, she replied: "It is beautiful and it is necessary to have

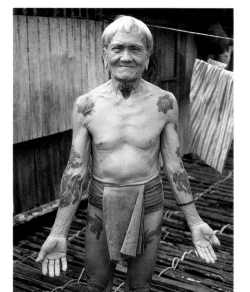

Above: Traditional Iban tattooing in Sarawak, Malaysia.

CHRIS WROBLEWSKI/SKIN SHOWS

a wound in this life because it will be good for the next life. Also the tattoos will not fade and it is said that when one dies, who has been tattooed, that person can sell their tattoos in the heavens. I do not know exactly why one sells their tattoo; maybe they sell it if they are having a difficult time getting into the heavens." (13)

In the Gujarat area of northwestern India, tattooing is still widespread among the "tribal" rural communities, but the traditional tattoos are increasingly perceived both as old-fashioned and as marking the wearer as a low-caste "country bumpkin." Thus, while traditional designs are dying out, particularly those tattooed by women on each other, there is an increase in more modern designs tattooed on men by professional traveling tattooists.

Perhaps one of the saddest losses of traditional tattooing has occurred in North America, where so many of the traditional cultures were ruthlessly irradicated by European immigrants:
Tattoo was widely distributed in the Americas, usually connected with ethnic identity, social role, or status. In western North America, lines tattooed on women's chins (as for the Inuit) usually indicated group membership and/or marital status. More

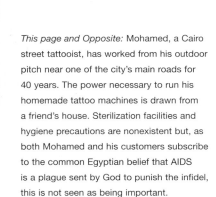

18

elaborate representational body tattoos for women, reflecting high status, were reported by the earliest visitors to Virginia and Carolina, and as far north as the Ontario Iroquoians. Along the northwest coast, tattooing for most groups was simple in design and casually performed, but young people of high rank were tattooed with elaborate crest designs in connection with major potlatches [local festivals]. Such work was particularly extensive among the Haida, covering the backs of the hands and upper surfaces of the feet, both arms from wrists to shoulders, chests, thighs, and lower legs, and sometimes also cheeks and back. Men's tattoos in the southeast typically had martial associations. In Louisiana, killing an enemy or other war honors entitled a man to have a tomahawk or war club tattooed on his shoulder above a symbol identifying the nation against which his accomplishment was realized. Outstanding warriors among the Chickasaw were distinguished by their tattoos; men who affected marks they did not deserve were publicly humiliated and forced to suffer their removal. **(14)**

It is profoundly ironic that these long-lost tattoo traditions are now being revived and revered, not only by the American great-grandchildren of the settlers who originally destroyed those traditions, but also throughout Europe, in Australia and New Zealand, and in other strongholds of our all-pervasive Western culture.

There are many theories as to which social, philosophical and economic changes have caused so many Westerners to reject transient fashions and instead embrace the permanent body arts of traditional and tribal societies. But, whatever the cause, many of us are now choosing to be – rather than possess – works of art.

This page and Opposite: Mohamed, a Cairo street tattooist, has worked from his outdoor pitch near one of the city's main roads for 40 years. The power necessary to run his homemade tattoo machines is drawn from a friend's house. Sterilization facilities and hygiene precautions are nonexistent but, as both Mohamed and his customers subscribe to the common Egyptian belief that AIDS is a plague sent by God to punish the infidel, this is not seen as being important.

Tattooing is completely unacceptable to the vast majority of Egyptians, partly because Muslims observe the Koran's proscription against the depiction of any image of the human body, and partly because tattooing is associated with the lowest classes.

Mohamed therefore finds all his clients from the ten percent of the population who are Christian Copts, a sect who are traditionally tattooed as children with a small cross on the insides of their wrists. Many of Mohamed's designs are on religious themes, but for this minority the wearing of any tattoo marks them as Christians in a Moslem world.

One popular design, taken from an old folk tale, shows a lion holding a sword; this is often chosen for the back of the hand: **The motive for the most common tattoo is simply the fear of getting lost. Little boys have their names, birthday, and sometimes their address tattooed on the inside of their arm. All the little tyke has to do if he finds himself lost in the maze of Cairo's back streets is to grab an adult and roll up his sleeve. (15)**

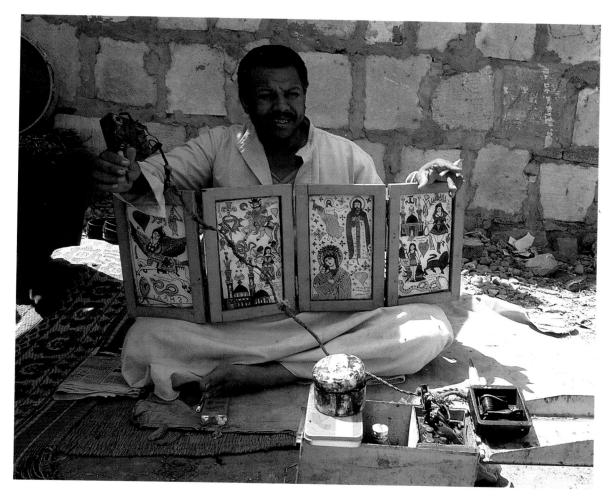

Mohamed never places designs on the back, as this prevents the owner from looking at, and enjoying, them. Instead, the bigger designs are tattooed onto the chest.

Because this is a more private location, sexually exciting designs – such as dancing girls, which look so innocent to our eyes – are often chosen. These sexual images are highly taboo – unlike, for example, the black bird tattooed onto an old man's temple:

. . . after he had gone to a healer complaining of headaches. Pointing to the bird and grinning, the man said: "I am better now, the headaches have flown away." (16)

ALL PHOTOGRAPHS BY
TIM COLEMAN

19

Mohamed's trade is disappearing. His father tattooed British soldiers during the Second World War, as his father before him tattooed Turkish soldiers, but today there are no soldiers and the young, who do not want to be marked forever as members of an underclass, are increasingly turning their backs on tattooing. He only has three colors of ink left and sees no prospect of getting any more.

recent
history

When the Emperor Constantine banned tattooing throughout the Roman Empire in A.D. 325, he was not only giving official approval to a common prejudice, he was also setting a precedent that would be followed by other law-makers – for example, by Pope Hadrian I in A.D. 787 – in years to come. Why did such prejudice and official disapproval persist? Two main arguments were used against tattooing. First, the Old Testament prohibited it, as in Leviticus chapter 19, verse 28: "You shall not make any cuttings in your flesh on account of the dead, or tattoo any marks upon you." Secondly, there is the belief that, if we accept the Bible's assertion that God made Man in His image, then any "mutilation" of that image is not only a mutilation of God's handiwork, but also of the image of God himself. Of course, those who proposed this argument continued to shave, wear make-up, wigs, and jewelry, and to cut and style their hair as a means of making their appearance more acceptable to other men, if not to God.

However irrational or unjust, such convictions continued to prejudice Westerners against those who had been tattooed. Given that tattooing was considered to be un-Christian, it is ironic that one of the ways in which it was re-introduced into Western Europe was by the Christian Crusaders of the eleventh and twelfth centuries, for whom it became the fashion to get a tattoo as a souvenir of visits to the Holy Land. This custom was carried back home by the Crusaders, and, it seems, by earlier travelers to the Holy Land.

For, following the Battle of Hastings in 1066, when the English King Harold could not be found among the numerous mutilated corpses, Edith, who had formerly been the King's mistress (and who was therefore intimately familiar with his naked body), was brought to the battlegrounds. She recognized his body, and was able to prove that this was indeed the King by examining his unique tattoos:

On the breast just above the silenced heart were punctured, in the old Saxon letters, the word "Edith"; and just below, in characters more fresh, the word "England". [17]

The practice of being "pricked" with designs on visits to Palestine continued for many years among the soldiers and sailors who ventured overseas, and was taken up by pilgrims visiting the holy sites:

One of the earliest records is that of William Lithgow, who visited the Holy Land in 1612: "Earley on the morrow there came a fellow to us, one Elias Areacheros, a Christian in habitour at Bethleem, and purveier for the Friers; who did ingrave on our severall Armes upon Christ's Sepulcher the name of Jesus, and the Holy Crosse; being our owne option, and desire; here is the Modell therof. But I decyphered, and subjoyned below mine, the four incorporate Crowns of King James, with this inscription, in the lower circle of the Crowne, Vivat Jacobus Rex: returning to the fellow two Piasters for his reward." [18]

This custom continued into the eighteenth and nineteenth centuries, and a wide variety of designs was offered, including the following:

. . . a plan of the Via Dolorosa, Christ carrying the Cross, the Holy Grave and Ascension, and the Jerusalem Coat of Arms, together with various inscriptions. [19]

Indeed, by the mid-nineteenth century, so fashionable was it to acquire a tattoo that even British Royalty joined in:

Edward VII, as Prince of Wales, was first tattooed on a visit to Jerusalem as part of the Grand Tour. He was accompanied by, among others, Lieutenant-Colonel Charles Keppel, and in 1862, when the Prince was twenty, they called upon the famous Levantine tattooist, Francois Souwan: "The Prince chose a design incorporating the Cross of Jerusalem which Souwan duly tattooed on his forearm. Souwan recognised his customer as the Heir Apparent to the British Crown, begged him to accept the tattoo as a mark of respect, and refused payment." [20]

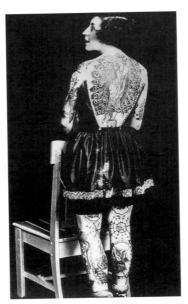

Above: In the 1920s-1930s, hundreds of tattooed ladies worked in circuses and carnivals under wonderfully evocative names such as Smithy the Tattooed Doll, Lotta Pictoria, and Artoria The Fairground Freak.

THE SKUSE COLLECTION

20

Right: American Danny Styron posing in front of his circus wagon.

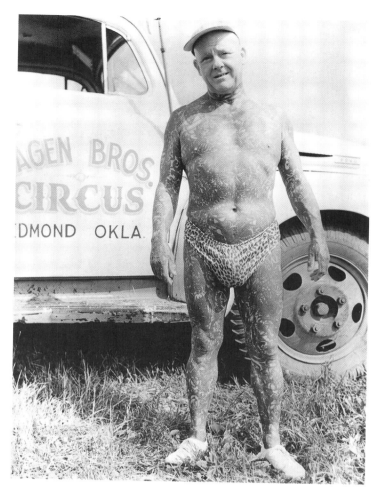

A similar urge to acquire a souvenir of adventures overseas was the motivation behind the main influence upon Western tattooing until the present day, that is, the exploration of distant shores by the world's navies. Captain Cook, his historian and naturalist Joseph Banks, and others of the crew returned from their 1769 voyage on the *HMS Endeavour* to the South Seas and New Zealand with wonderfully detailed descriptions of the body decorations of the natives, and a new word "tattoo" to describe these decorations. But a few of the crew also returned with their own tattoos:

In the words of Sidney Parkinson: "Mr Stainsby, myself and some others of our company underwent the operation, and had our arms marked: the stain left in the skin, which cannot be effaced without destroying it, is of a lively bluish purple, similar to that made upon the skin by gunpowder." (21)

The practice of sailors acquiring tattoos developed in subsequent years, first becoming a fashion, then a superstition, and finally a tradition. By the end of the eighteenth century tattoos were so common that some marks were registered by Britain's Royal Navy. It is from these records that we know that over 80 percent of the *Bounty* mutineers were tattooed. Examples include: Fletcher Christian, who had a star on his left breast and tattoos on his backside; George Stewart, who had a star on his left breast, a heart and darts on his left arm, and tattoos on his backside; Peter Heywood, who was heavily tattooed; and Edward Young, who had a heart and dart on his right arm with the initials EY under it and the date, 1789.

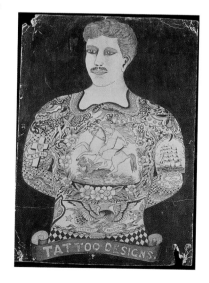

At first, such tattoos were drawn by native tattooists but, as some sailors acquired the basic skills, the salts learned to tattoo each other on board ship. Later still, it became the fashion to visit professional

Left: Self-portrait of William Henry Thomas who was born in London in 1872, and who worked as a tattoo artist from 1902 to 1966, often traveling with fairs and working out of a tent.

tattooists, who set up shop in ports around the world (many of them had previously been sailors themselves). Getting tattooed became very much a part of becoming a sailor and belonging to that world of the sea, so much so that it was estimated that by the end of the nineteenth century 90 percent of all sailors in the U.S. Navy were tattooed:

In the [words] of one U.S. seaport tattooist early in this century, a sailor without a tattoo was "like a ship without grog – unseaworthy!" (22)

Anchors, ships in full sail, national flags, and similar designs were obvious choices for the seamen's tattoos, but superstition and tradition also influenced a sailor's choice of design. One of the reasons for being tattooed was highly practical: it increased the chances of being identified

if lost overboard. But this was soon being taken one step further – by being tattooed with the sign of the Cross or some similar religious image, a sailor would hope to ensure that his body would at least receive Christian burial rites if lost at sea. There is also a belief that large back tattoos of Christ's head, Christ on the Cross, the Last Supper, the Rock of Ages, and similar religious images originated with the desire of sailors to stay (or at least moderate) the hand of anyone administering a beating with the rope's end across the back, a standard form of shipboard punishment at that time.

Other designs symbolized the major events in a sailor's life:

When you had gone 5,000 miles at sea, you got a bluebird on your chest. When you'd gone 10,000 you got the second bird on the other side. When you made your second cruise you got a clothes line with skivvies and girls' stockings between them. If you crossed the equator you got a Neptune on your leg, and for security you got a pig on one foot and a rooster on the other, a charm that would keep you from drowning at sea. Turnscrews on the rear end (ships' props) would help you reach shore if you washed overboard, and they usually read "40 knots no smoke" or "TWIN SCREWS – STAND CLEAR." A dragon showed you had crossed the international date line and every sailor had that, or if he wanted you to think he had been to Honolulu, he had a hula girl on his arm so he could make her dance. (23)

It is often presumed that tattooing among sailors is, and was, the preserve of the lower ranks, but this is not the case. From the Victorian period there is the famous case of the British Admiral, Lord Charles Beresford, whose enormous tattoo of "The Hunt" decorated his back from his shoulder to buttocks. But even more high-ranking were the British Prince George, Duke of York (later King George V) and his brother Prince Albert, Duke of Clarence, who in 1881, while visiting Tokyo as part of the crew of *HMS Bacchante*, both had dragons tattooed on their forearms (as did many of the crew). Prince George later added several

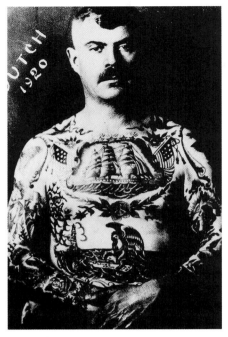

Above: A 1920 portrait of "Dutch," an American who was tattooed with a substantial collection of traditional, mostly patriotic, American designs by Percy Waters of Detroit, Michigan.

THE SKUSE COLLECTION

further tattoos to his collection, including one done six months later on a tour of the Holy Land, when he visited the tattooist his father had seen in 1862, receiving an identical tattoo.

The young princes were not the only members of high society to enjoy being tattooed. Admirals, Earls, and Lords – and also their ladies – joined in the fun. By August 1897, according to *New York World*, 75 percent of American society women were tattooed. Lady Randolph Churchill (Sir Winston's American mother) could display (or conceal) a snake around her wrist. The Duchess of Marlborough – a Vanderbilt – also had at least one tattoo, as did one of the Duponts and a Rothschild. Dorothy Parker boasted a heart tattoo, while her husband, Alan Campbell, chose an elephant rampant. The fashion for tattoos in high society continued until well after the First World War, but declined in the 1920s. Among the sailors (who remained much more important customers for the tattooists' parlors), tattooing also lost popularity at this time, but it soon picked up again with the advent of the Second World War.

During the same period that the tattoo was becoming an accepted "badge of belonging" for the sailors of all the world's great navies, "tattooed curiosities" were being displayed to fascinated onlookers at fairs and circuses. Some sailors had returned from voyages overseas with descriptions of tattooing, some with drawings and some with examples of tattoos proudly displayed on their forearms, but some returned with much more than that.

As long ago as 1691, an explorer named William Dampier bought "Prince Giolo" from a trader in settlement of a debt and brought him to London, England, where he was exhibited to an excited public which included King William and Queen Mary. The publicity claimed that he was painted with dyes that could protect him from the venom of any creature, but Dampier admitted elsewhere that Giolo's decorations (which from the descriptions could well have been Marquesan tattoos) had in fact been

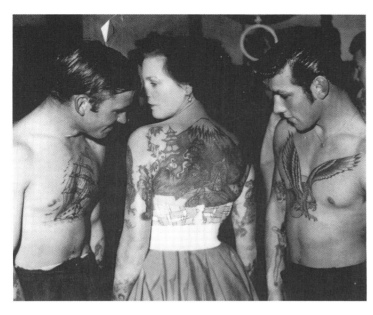

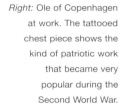

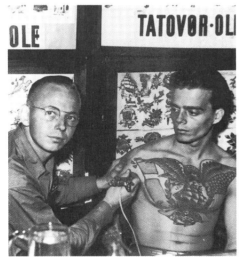

Right: Ole of Copenhagen at work. The tattooed chest piece shows the kind of patriotic work that became very popular during the Second World War.

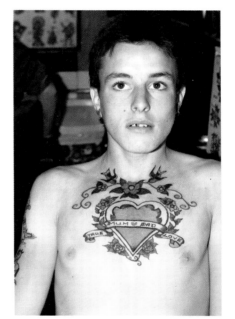

23

pricked into his skin. Dampier hoped to make a healthy profit from displaying his slave, but this innovative scheme came to nothing when the latter became ill and died of smallpox.

Nevertheless, many others followed where Dampier had led:

In 1723, two American Indian princes were exhibited in European fairs, followed in 1774 by Omai, Captain Cook's contribution from the second South Sea expedition. Omai was not, as has been suggested, heavily tattooed, but, as described by Sir John Cullum F.R.S. at a dinner at the Royal Society in 1775 "the backs of his hands are tattowed with transverse lines not continuous but distinct blu-ish spots; his posteriors are the only other parts tattowed". The man was considered important enough to have his portrait painted by Sir Joshua Reynolds, and it was exhibited at the Academy in 1776. Boswell also recalls Johnson's meeting with him, and his comments concerning the

"elegance of his behaviour" which he explained by the fact that "he had passed his time, while in England, only in the best company; so that all he had acquired of our manners was genteel." (24)

In 1804, meanwhile, the Russian explorer George H. von Langsdorff visited the Marquesas islands where he met Jean Baptiste Cabri, a French deserter who had lived there for many years, married a Marquesan woman, and been extensively tattooed. Cabri returned with von Langsdorff and took up a career in the theater, touring Europe and telling wonderful stories of his adventures among the savages. He eventually died in obscurity in France in 1818.

The first English "tattooed wonder" was John Rutherford, a sailor who returned to his hometown of Bristol in 1828 after being captured by Maoris in New Zealand in 1816. His was an exciting story of being held

24

Right: George Davies, age 80. George did not start collecting tattoos until he was 62 years old and now has so many that, shortly before this photograph was made, he had a thimble tattooed on him so that people would be able to play his special version of the old parlor game "Hunt the Thimble." He waited until he retired before having his arms tattooed, as he previously ran a delicatessen and felt that showing tattooed arms would put off his customers. All of George's tattoos are by Harry Potter of Wickford, England.

HENRY FERGUSON

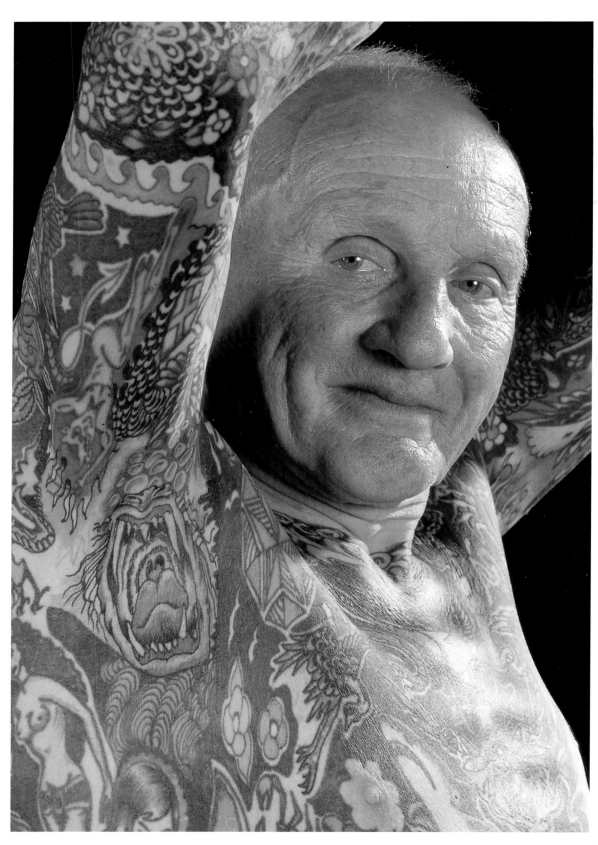

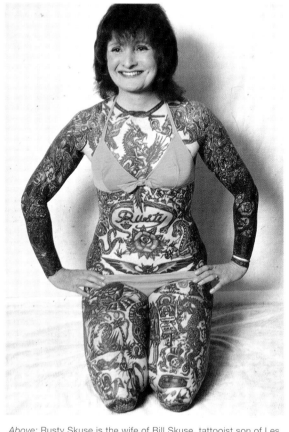

Above: Rusty Skuse is the wife of Bill Skuse, tattooist son of Les Skuse. She became very well known in the 1970s as the "World's Most Tattooed Woman," earning herself a place in the *Guinness Book of Records*. She also became a tattooist in her own right and continues to be a popular figure on the British tattoo scene.

THE SKUSE COLLECTION

prisoner for ten years, being forcibly tattooed by two priests, accepted as a member of the tribe, made into a chief, offered as many brides as he liked from over 60 Maori maidens, and then marrying two of the daughters of the ruling chief. After a life enjoying tribal pursuits such as head-hunting, he was rescued in 1826 by a ship, and taken to Hawaii, where he spent one year, and married another native princess. He then returned to England, where he earned his living by telling stories and displaying himself at a traveling fair. Although he later admitted that not all his tales were entirely true, his Maori tattooing was certainly completely genuine.

There is some question over who was the first to exhibit a tattooed man in the United States: Dan Rice, or the legendary showman Phineas T. Barnum, who in 1842 opened his "American Museum" in New York City. This was a collection of entertainments and exhibits which included what Barnum described as "mysterious deviations from nature's usual course:"

One of the original human oddities at Barnum's American Museum was James F. O'Connel, who enjoyed the honor of being the first tattooed man ever exhibited in the United States. He entertained his audience with tall tales of exotic adventures like those told by Cabri and Rutherford. According to his story, savages on a South Sea island captured him and forced him to submit to tattooing at the hands of a series of voluptuous virgins. He discovered to his great distress that island custom obliged him to marry the last of the maidens who had tattooed him. She was, of course, a princess. (25)

In 1873 the position of "tattooed man" at P.T. Barnum's "Great Traveling Exposition" – billed as the largest circus in the world – was filled by Prince Constantine, an elaborately tattooed Albanian Greek who was famous not so much for the stories he told (which bore a remarkable resemblance to the stories of Cabri, Rutherford, and O'Connel) but for his exceptionally beautiful tattoos:

. . . [Prince Constantine's tattoos] consisted of 388 symmetrically arranged and closely interwoven images that covered his entire body, including his face, eyelids, ears and penis. The designs, according to his publicity, consisted of "crowned sphinxes, dragons, serpents, monkeys, elephants, leopards, tigers, lions, panthers, gazelles, cats, crocodiles, lizards, eagles, storks, swans, peacocks, owls, fishes, salamanders, men and women, fruit, leaves and flowers, most of them quite small but exceptionally exact in their details." (26)

In 1870, Prince Constantine was exhibited in Vienna, to great acclaim:

. . . he was examined by a number of oriental experts, who confirmed the fact that the tattoos were in the best Burmese style As it was established that the man had spent many years in Southeast Asia, the consensus of opinion was that he had had himself deliberately tattooed in anticipation of going into show business. (27)

Prince Constantine was clearly a man of vision: his salary at Barnum's was $1000 a week. He chose to be tattooed, and in doing so created a whole new profession. He also set a style of tattooing (total coverage made up of innumerable small images) that continues to this day, and that was followed by the hundreds of other tattooed men and women who exhibited themselves in the freak shows that were popular attractions at the fairs, carnivals, and circuses which traveled throughout Europe and the United States. These exhibitionists reached their peak of

25

Right: Bianca from Italy displays her sacred heart design, tattooed by Fred Corbin, and a traditional Japanese right-arm tattoo, by Horiyoshi III. The "folk art" traditions of tattooing are now being rediscovered by today's artists, who are producing many beautiful examples of neotraditional tattoo art.

WILLIAM DEMICHELE

popularity in the 1920s, but then faded out of fashion. The last survivors went out of business in the 1950s.

The most singular exception to this prevailing style of circus tattooing was Major Horace Ridler, known as The Great Omi. Born into a wealthy British family, Ridley was privately educated, joined the army, was decorated for heroism in the First World War, and eventually received an honorable discharge with the rank of Major. But, after drifting around for several years, he realized that the only occupation that held any appeal for him was in the circus. He had no skills appropriate to a circus job, but he did have several tattoos. He thought of a brilliant plan: after much persuasion George Burchett, London's most famous tattooist, agreed to tattoo a pattern of zebra-like black stripes over his entire body, including his head. Burchett made sure that Ridler realized that he would be an unemployable freak and social outcast, but Ridler knew what he wanted. The tattooing took three sessions a week for over a year, and once it was complete Ridler filed his teeth to points, pierced his nose so that he could wear a tusk, pierced and stretched his ear lobes, and pronounced himself The Great Omi.

Ridler's wife stuck with him through all of this, and when The Great Omi toured the circuses and music halls of Europe, with great success, she introduced him and appeared under the name "Omette." He traveled to the United States where he joined Ripley's "Believe It Or Not Show" in 1938, worked in New York and was one of the highest-paid performers in the Ringling Brothers' Barnum and Bailey Circus. At the start of World War Two he returned to England and attempted to enlist. When he was refused, he continued his stage career and performed many times for the troops and for war charities. He eventually died in 1969 at age 77.

Although a handful of tattooed circus performers still survive, The Great Omi was very much the last of a long line of circus stars. It would be fascinating to know his opinion of the new generation of selfmade, tattooed "freaks," such as the "Enigma" whose whole-body tattooing resembles a giant jigsaw puzzle, and who travels around with the Jim Rose Circus, earning his living as a real, live, performing "human curiosity" in the 1990s.

The circuses and carnivals of the late-nineteenth and early-twentieth centuries traveled not just with tattooed attractions, but usually with their own tattoo artist as well; the artist would provide decorations for circus workers and visitors alike. Paul Rogers (of the United States' best-known tattooing suppliers, Spaulding and Rogers) tattooed with a traveling carnival for many years. The majority of tattoo studios, however, were still situated in seaports, for sailors remained the most reliable customers.

Initially such Western tattooists worked, like so many native tattooists, by pricking their designs into the skin using needles and ink. In 1891, though, a technological revolution swept through the tattooing industry when the first electric tattoo machine was patented in the United States.

The electric machine has one great advantage in that it allows a tattooist to work much faster than is possible by hand, and the same design of machine, with very minor modifications, is still used by tattoo artists today. But if the tattoo machine brought huge advantages, problems still remained, for the inks that tattooists used were generally bought as powdered pigments intended for other purposes, and they were handmixed by tattooists to their own jealously guarded recipes. This meant that there was a wide variation in the colors used by different tattooists, particularly as regards their safety, brightness, and permanence. However,

Since the late 1980s, predispersed pigments with a greater ease of workability have come into wide usage. The average tattoo palette until the early 1970s was limited to black, red, green, brown, yellow, and occasionally white. Sailor Jerry Collins was the first to introduce a good blue and purple in the 1960s, but these

"Probably the most clichéd tattoo in Western society (especially to a nontattooed person) is a 'heart with Mom.' It distills everything odious about tattooing to a 'civilized' repressive eye: the barbaric practice of marking the flesh with needles and pigment manifested as a literal statement of our emotional roots." Don Ed Hardy (28)

were only in the hands of a few artists. Since that time the color range has expanded to include nearly every hue generally available in the painter's repertoire. (29)

Tattoo parlors were usually tiny spaces, often parts of other establishments such as barbers' shops, arcades, or carnival sideshows, in places that saw a lot of passing trade – harbors, seaside resorts, fairgrounds, red-light districts, or near military facilities. The decoration of the establishment was of great importance. The exterior was generally covered with enormous, garishly colored examples of tattoo-style artwork, flashing neon signs, bright lights, and anything else that would attract the attention of potential customers.

Inside were tempting displays of numerous sheets of "flash," designs from which customers could choose. Many tattoos were bought on impulse and it was vital that, whatever a customer might fancy, he or she could find it displayed there. If only a small selection of the flash could be displayed on the walls, as for some traveling tattooists, it would be mounted into a bound album that the customer could leaf through. Some of these sheets of flash were crudely drawn, but many examples were works of art in their own right, and are now widely collected. It is these "classic" tattoo designs, often incorporating hearts and flowers, pinups, religious motifs, daggers, and scrolls, that are now being re-discovered by today's tattooists and tattoo fans, and reworked into contemporary images that pay homage to this previously undervalued folk art. Flash was an essential part of the tattooist's stock-in-trade, and sheets were widely bought and sold, exchanged, and otherwise acquired:

Each design required an accompanying stencil to transfer the line image to the skin. Early in the century these were made by drypointing celluloid (a highly combustible material), later replaced by acetate. 'Cutting' stencils was an art in itself, and good practice for the artist's hand in creating decisively tattooed outlines. Powdered charcoal was rubbed into the incised lines, then pressed onto the shaved area (which had been coated with vaseline). A firm, even depth of line in the plastic was necessary to transfer a sharp, clear outline onto the skin, and withstand many printings. By mid-century, dye pencils on rice paper or vellum became the standard method of transferring one-of-a-kind designs to avoid the more laborious method of cutting an acetate stencil Dye transfer patterns have the considerable advantage of remaining visible on the skin well into the tattooing process, whereas acetate and powdered charcoal imprint methods are fragile and smear easily. This necessitates the awkward method of tattooing from one corner of the image up. Currently both of these methods have been rendered largely obsolete by the use of stencil machines that produce a durable dye transfer image off a photocopy instantly. This is perhaps the most important innovation for the contemporary tattooer, enabling the reproduction of extremely complex effects. (30)

Although the great majority of Western tattoos have been copied from sheets of flash, there have always been a small minority of tattoo artists

27

who have also been able to work freehand. It is unusual for an artist to work in this way, but some customers value this more time-consuming – and expensive – approach because the work that they receive is unique.

But many have been frustrated in this desire for uniqueness by the popularity of the camera. If you have a tattoo of which you are particularly proud, you will usually wish to show it to others who will appreciate its artistry. They will often want to photograph it, photographs are passed between tattoo fans or published in books and magazines, the photograph is found by another tattoo fan who likes the design so much that he or she takes it to their tattooist and asks for the same design – unfortunately, no one has yet succeeded in copyrighting a tattoo!

Above: Ankle tattoo by Bob Roberts; waist tattoo by Louis Molloy.

JAN SEEGER

"If you're supposed to have a tattoo,

the tattoo god will speak to you."

Suzi (1)

section 2: tattoo styles and influences

Tattooing in the West today draws inspiration from a wealth

of different styles. Influences include non-Western cultures.

other Western popular art forms, and – most of all – the

diverse myths. legends. and stories that have become

incorporated into both our culture and our individual

fantasy worlds

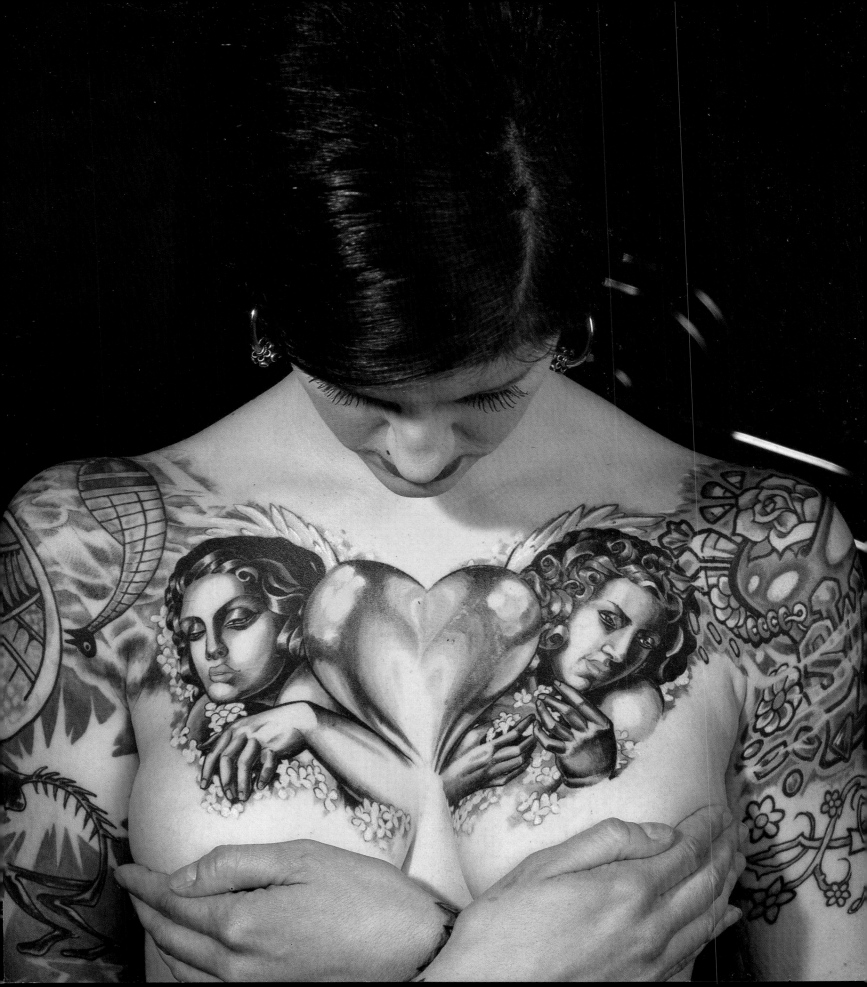

japanese
the art of the hero

Tattooing has been practiced in Japan since at least the fifth century B.C., variously as beautification, for magical purposes, and as a means of marking criminals. The exquisite style of Japanese tattooing that we know today, however, sprang from the publication in the mid-eighteenth century of *Suikoden (The Water Margin),* a Japanese translation of the fourteenth-century Chinese novel about a twelfth-century band of Robin Hood-like outlaws. This anti-establishment tale became very popular in the early 1800s and was published in many different versions, most of them illustrated with woodcut prints.

A number of the heroes of the original Chinese novel were tattooed: Shishin was tattooed with nine dragons, Rochishin with flowers, and Busho with a tiger. Colorful illustrations showing these and other heroes adorned with tattoos were to provide the basis of Japanese tattooing as we know it today.

The *Suikoden*-inspired tattoos came to be particularly associated with the fire fighters of Edo, Japan's capital. Gangs of unemployed ruffians were recruited by the government to make up the country's first full-time fire service. They admired and emulated the brave *Suikoden* heroes and copied them by getting tattooed all over, except for their heads, hands, and feet. Their designs traditionally incorporated water symbols such as dragons and carp, and each fire-fighting group chose different symbols with which to be marked.

As the popularity of tattooing spread throughout the working population of Edo, the styles and images used evolved, and by the mid-nineteenth century ideas about appropriate subjects and placement were established. Each tattoo "suit" was one large, integrated design that covered the back, buttocks, chest, stomach, and loins, ending mid-forearm and mid-thigh. The main development in Japanese tattooing since then has been the emergence of the *kawa* (river) tattoo, which leaves a strip of clear untattooed skin down the center of the chest, stomach, and thighs.

Above: Horiwaka tattooing in the traditional manner in his studio in Tokyo. Japanese tattoo masters traditionally assume a professional name starting with Hori, named after the nineteenth-century trade guild of tattoo experts, the *horishi*. When a tattoo master retires his title, along with his business, may be passed on to his apprentice, often a son or other male relative.

CHRIS WROBLEWSKI/SKIN SHOWS

Throughout history, tattooing in Japan has regularly been banned by sumptuary laws – but it has nevertheless survived. Ironically, the greatest damage to Japan's tattoo tradition occurred in the mid-nineteenth century, when Japan's government relaxed its isolationist stance and opened the country to Western influences. Concerned that Westerners would despise it, the traditional art form was banned by the country's rulers. Fortunately, the unemployed tattoo masters soon discovered a new clientele among Western sailors and visiting dignitaries, including no less a personage than Britain's King George V who, when Duke of York, had had a dragon tattooed on his forearm.

It is not surprising that Japanese tattooing, with its integrated compositions, brilliant colors, thrilling imagery and technical expertise, has inspired many Western tattooists to produce some of their finest work.

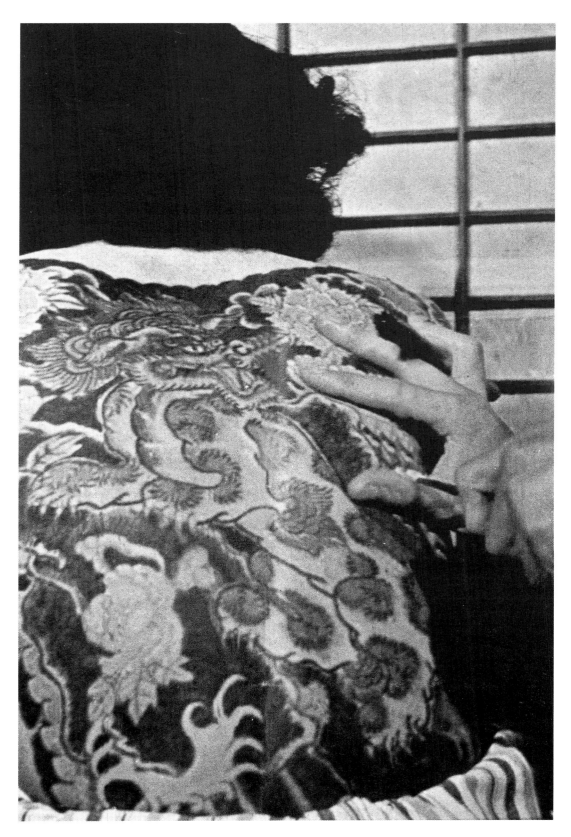

Left: A Japanese girl with a lion tattoo. **The all-powerful, all-protective Chinese lion [is] symbolic of courage and fortitude. (2)**

The traditional Japanese tattooing process begins with a visit to the tattoo master by the client, who will usually come with an introduction from another client or mutual acquaintance.

The client will choose from the master's designs which are often based on artists' prints, and the outline will be drawn freehand onto the skin using a marker pen. (Outlines were traditionally drawn in ink, but permanent markers are now used because the ink from these stays visible on the skin for several days.) The outline can then be tattooed in several sessions using *sumi*, the thick charcoal-based ink used in brush writing, and a tool consisting of a bundle of four needles set into a wooden handle: **The tool is held in the right hand. The left hand stretches the skin. Between the ring and little fingers of the left hand the master holds a brush charged with *sumi*. The needle tool is brushed against this, collecting ink, and is then pushed, at an angle, directly into the marked line. This process is repeated with each thrust. A smooth and easy motion, somewhat like that of a slow sewing machine, is maintained, and bit by bit the line is inked in. (3)**

The design will then be colored in over many more sessions. Originally only black, red, and occasionally brown were used, although different shades can be created by diluting the colors. A tool holding up to ten needles, all inserted under the skin to the same depth, is used to fill large areas without shading. A tool holding fewer needles is used for shading: this can either be pressed lightly into the skin, or inserted more deeply with the needles closer together where darker shades are required.

31

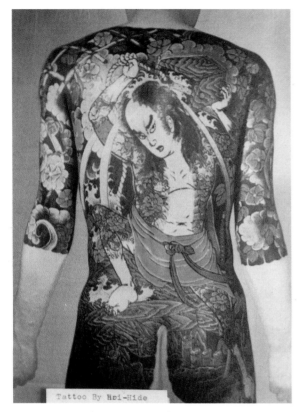

Above: Photographs of work by Japanese tattoo masters, such as this example by Hori Hide, were widely circulated among Western tattoo artists and enthusiasts. This particular tattoo depicts a man who is himself tattooed – probably one of the heroes of the *Suikoden*.

The shape of the tattoo shown, covering the back from neck to thighs, and the arms down to the elbows, is the Japanese shape most commonly seen today. This style of tattoo can be completely covered by a traditional *happi* coat.

THE SKUSE COLLECTION

Right: A traditional Japanese tattoo is always the work of just one man, but Western traditions are very different. Here, Neely of Santa Monica, California, displays work by several tattooists. The koi carp and designs on shoulders, sleeves, left thigh, and buttocks, and "foo dog with peonies" on Neely's ribs are by Jesse Tuesday; the elbow wraparound is by Riley Baxter; the right thigh, buttocks, and "dragon with dragon robes" on ribs are by Kevin Quinn; and a gray chest panel of "hokusai-style dragon" and all connecting gray work are by Pote Seyler.

WILLIAM DEMICHELE

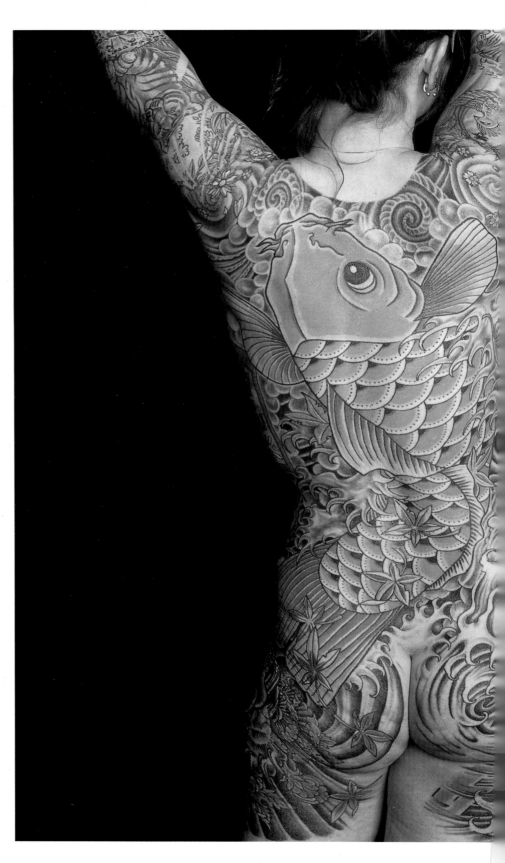

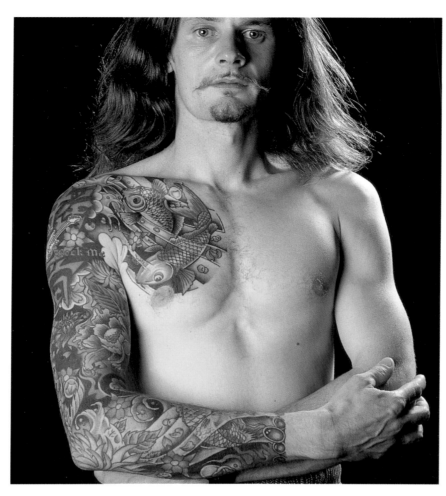

Left: Paul Snooks' arm and shoulder fish tattoo drawn by Phill J. Bond of Torquay, England. Waterbeasts are traditionally associated with the ancient Edo fire fighters who first popularized classical Japanese tattooing:

One of Japan's most popular aquatic subjects is the koi, decorative carp. Fish are generally symbolic of good health, good luck and plentiful food. The carp specifically represents strength, courage and perseverance. An ancient legend adapted from the Chinese relates that the carp with the greatest endurance and fighting strength can leap the Dragon Gate and be transformed into a dragon, to enjoy everlasting happiness. (4)

HENRY FERGUSON

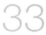

33

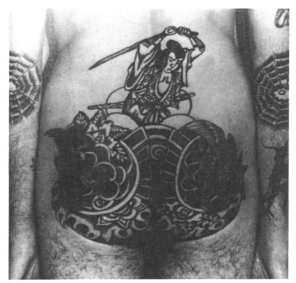

Left: Japanese-inspired buttocks tattoo with Samurai swordsman by Les Skuse of Bristol, England.

THE SKUSE COLLECTION

tribal – ancient designs for modern primitives

"Tribal" describes both the traditional tattoos of people such as the Ibans or Sea Dayaks of Sarawak in Malaysian Borneo, the Hawaiians, Maoris, and Samoans, and the immensely popular Western tattoo style that has evolved in recent years based on those people's designs.

In contrast to traditional Western tattoos of pictorial motifs, names, scrolls, and flowers executed in bright colors and outlined in black, tribal tattoos are essentially solid black designs with highly stylized or abstract, often geometric, patterns. Instead of treating the skin as a canvas on which to paint a picture – for example a ship in full sail – tribal tattooists use and exploit the three-dimensional nature of the human body, enhancing its muscles and curves with graphically simple designs. Tribal tattoos look just as impressive from a distance as they do when viewed close up.

Although the traditional tribal tattooing instruments and materials are very simple (being made from the materials to hand such as wood, bone, and shell) the Western tattooist usually uses the much faster and less painful electric machine. Either way, the execution of a successful "tribal" tattoo requires great skill. American tattooist Cliff Raven was one of the first to explore the possibilities of this style, and he has produced much exciting and influential work since the early 1960s. A breakthrough came in 1982, when Don Ed Hardy published his ground-breaking book, *Tattootime No.1: New Tribalism*,(5) featuring tribal work by master tattooists such as Raven and San Franciscan Leo Zulueta. The images in the book opened everyone's eyes to this "new" way of approaching tattooing, and the impact of that revelation on tattoo art in the West is still being felt today.

Many of the traditional cultures that provided the original "tribal" inspiration have now begun to enjoy positive feedback from this Western interest. After generations of being told by missionaries and colonial authorities that tattooing was evidence of their despicably "primitive" nature – indeed, in many cases they banned the practice altogether – Samoans, Tahitians, and Maoris are today not only rediscovering their own tattooing traditions, but finding that these traditions are in fact now envied by many Westerners.

Traditional Polynesian tattoo artists are regularly invited to work at Western tattoo conventions and, just like the sailors and explorers of the past, late twentieth-century tourists now bring back their own beautiful examples of traditional tattooing as souvenirs of their exotic vacations.

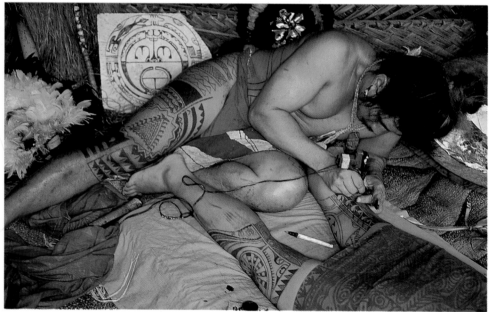

Above: Nano tattooing his wife Mihinoa in Tiki Village, Tahiti. He executes beautiful, traditional designs using modern tattoo machines. Nano works in a picturesque traditional building located near the Club Méditerranée vacation complex.

CHRIS WROBLEWSKI/SKIN SHOWS

Opposite: Tribal-style back piece on Brian of California by Alex Binnie of London.

JAN SEEGER

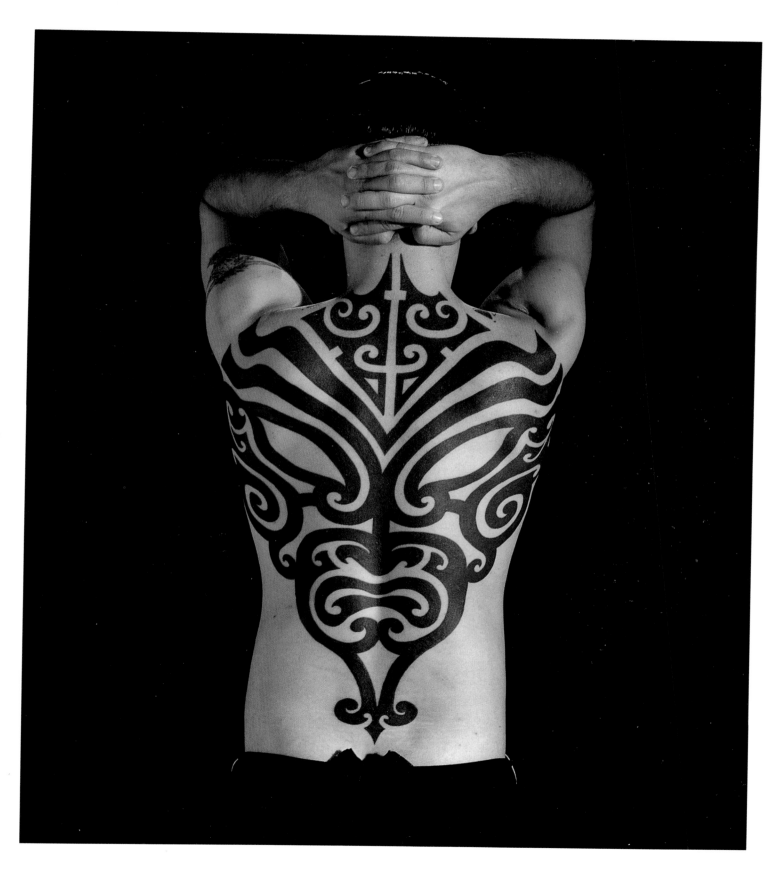

Below: Calf design on Kevin Stevens by Alex Binnie: **I began doing mainly abstract black tattoos, they are good to start off with because they allow some margin of error! I like anything bold, solid, with a definite shape to it and a heavy outline. (6)**

HENRY FERGUSON

Right: Monica of New Springfield, Ohio, who has a particularly flattering waist/lower back tattoo by Jeremy Caughey.

WILLIAM DEMICHELE

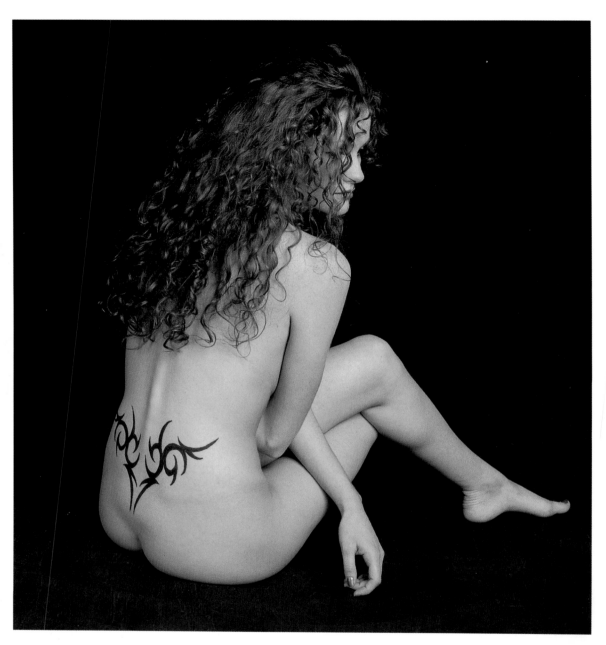

"The pre-tech style may be attractive to some as a way to plug into their own past, as with the modern Samoans, or with the race's past in general as a sort of 'back-to-nature' approach, or from simple admiration for the look of the style, as one may admire Aztec ceramics or Haida carvings. All are perfectly acceptable and reasonable motives for choosing it for one's own body or as a style to work in." Cliff Raven [7]

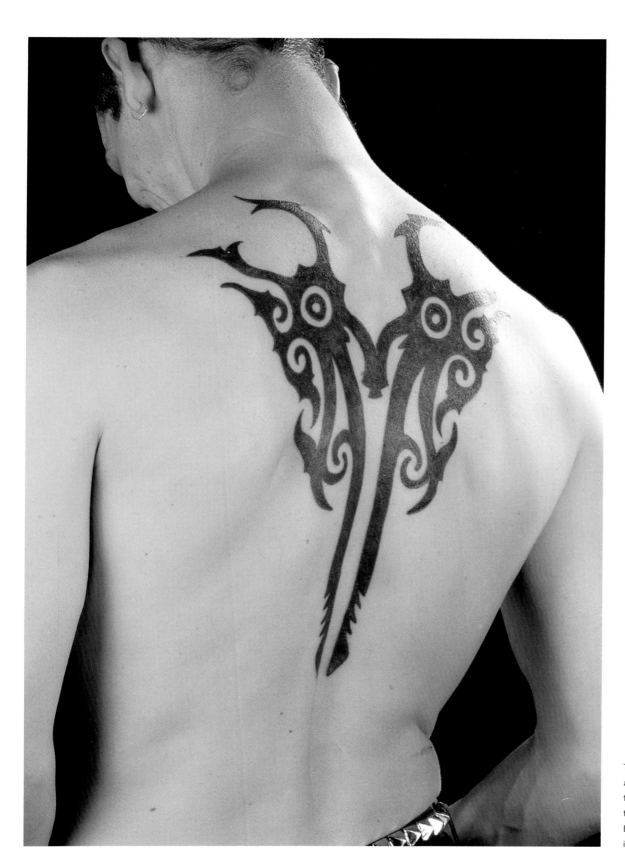

Left: Rich of "Reducer" *(see page 41)*. This design by Steve Herring is based upon the Dayak dog or dragon motif. Rich was tattooed by Tony Clifton.

JAMES DRURY

37

The three tattoos on this page and opposite are inspired by the beautiful monochrome tattoo designs of the Sea Dayaks, or Ibans, who live in Malaysian Borneo.

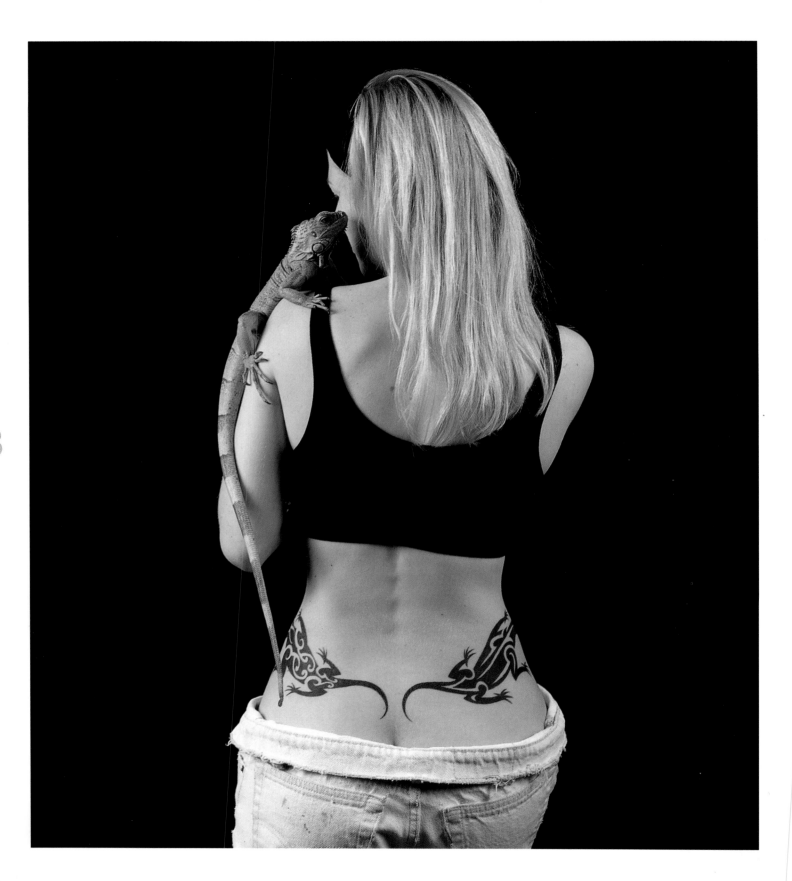

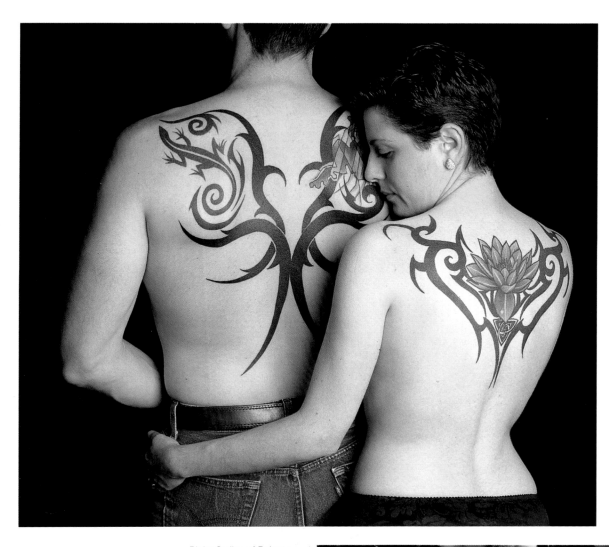

Left: Virginia and her husband James of Shoreline, Washington. His tattoos are by Leo Zulueta, her tattoos are by Vyvyn Lazonga. Two of the best respected names in American tattooing, Zulueta and Lazonga are particularly known for their exceptional and innovative tribal work.

WILLIAM DEMICHELE

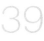

Right: Smilzo of Bologna, Italy, bares his tattoos by Marco Pisa of Italy. The designs are based upon the geometric patterns typical of many of the traditional tattoos of the Hawaiian Islands.

JAMES DRURY

Opposite: Erica, photographed in California. The graphic depictions of lizards by New Zealander Trevor Marshall are based on Maori tribal motifs.

JAN SEEGER

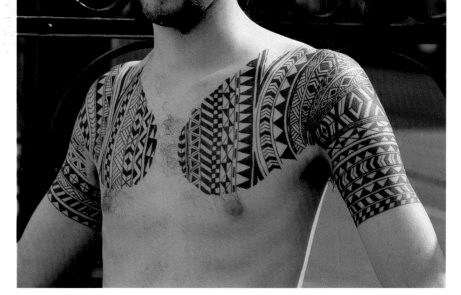

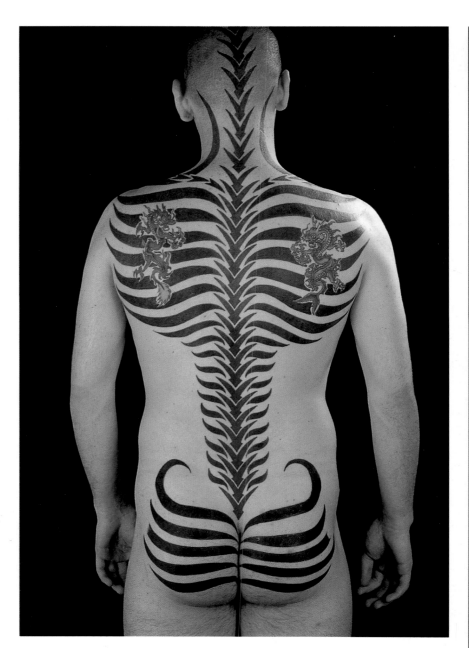

40

Above: B. Hogarth of London
sports tribal spine and
buttock tattoos by Alex
Binnie; his other tattoos are
by Lal Hardy of London.

HENRY FERGUSON

Left: "Reducer" displaying their tattoos by Tony Clifton, Steve Herring, and Alex Binnie. Alex Binnie writes: "Reducer" are a group of individuals with a common spirit and purpose in life. Their main form of communication is music, but that is only a part of a very powerful and complex whole. Reducer are a tribe, and they are for real, no bullshit, no compromises. One way they demonstrate this commitment to themselves and to each other is by their extensive use of tattoo. All the members of Reducer are tattooed – not as a form of dogma, but because they really feel it. Their tattoos demonstrate their common purpose and belief. Most of these tattoos are of the Abstract or Blackwork style – symbols, designs, patterns taken from Ancient and far-reaching sources. They dance over their skin as Reducer dance through life. The tattoos form a powerful part of their image and message – strong, committed, deep. Reducer are a gut level band – they function before words – skin, rhythm, dance, sex. Their tattoos are a part of them, they bind them together, they distance them from the mass. These pictures speak as loudly as their music. Listen; learn, there is something here for everyone. (8)

JAMES DRURY

Right: Alex Binnie with his tribal-inspired shoulder mask tattoo by George Bone.

HENRY FERGUSON

42

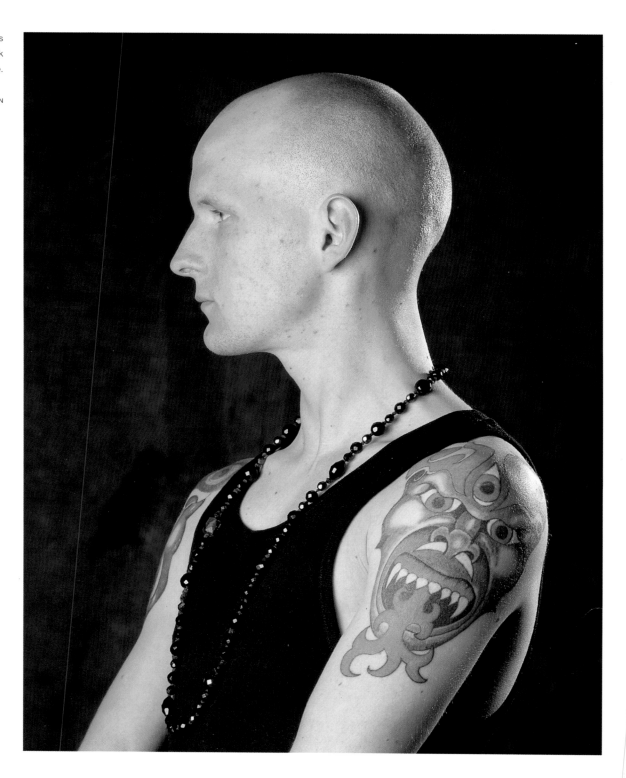

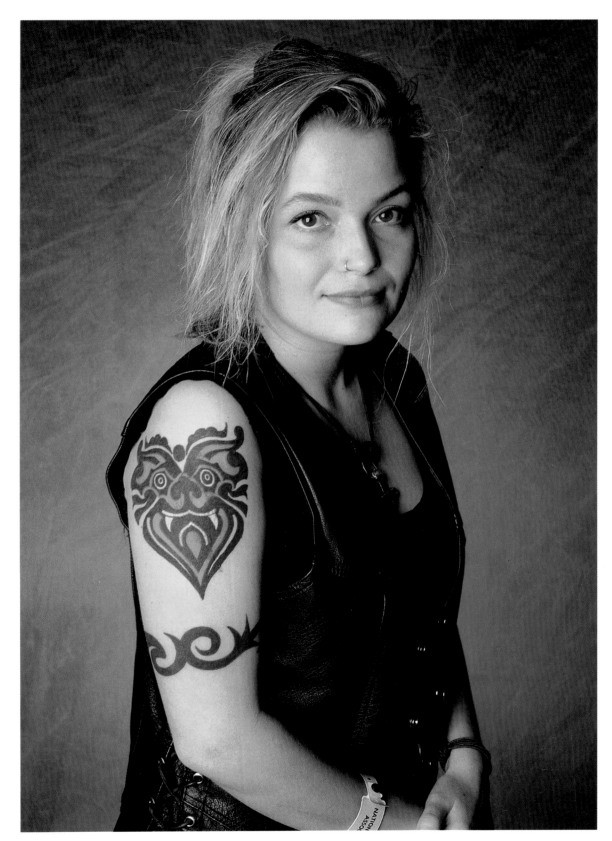

Left: Nina of Sweden has a tribal-inspired shoulder mask tattoo by Doc Forest of Sweden.

WILLIAM DEMICHELE

"There can be no doubt that the remarkable changes in [tattoo] style and practices during the past several decades have contributed significantly to the growth of tattooing's popularity. As designs have evolved from standardized flash to customized work that allows for creative contributions from clients, tattoos have become attractive to people who previously never would have considered marking their skin."

Mark C. Taylor [9]

43

native
american

The "Wild West" has long provided a rich source of folk heroes and antiheroes, but surprisingly few of these have translated into tattoo culture and iconography. The image of the Native American Indian, however, has provided a contrastingly powerful inspiration.

Today, Native Americans are perceived as possessing attributes and virtues that many tattooed people admire and identify with. They see them as members of an oppressed minority hounded to the brink of extinction; as a profoundly spiritual people in touch with the earth and its seasons; as self-sufficient nomads; as honorable, stoic, brave, fierce, and resourceful individuals, loyal to their tribe, and possessing all the most admirable of male virtues. In fact this view of the Native American is remarkably similar to the way that the *Suikoden* heroes were viewed by the indigenous people of early nineteenth-century Japan (*see pages 30-31*).

The earliest examples of the genre usually show the head of an American Indian male in full-feathered war bonnet, very much as the chief of the tribe was usually represented in cowboy and Indian movies. Or perhaps a brave is seated on his horse holding a feather-decorated spear, just as John Wayne might have seen him on a distant hilltop outlined against the sky.

Later, as tattooists and customers began to aspire to major pieces, the body would be covered on the scale of the great Japanese tattoos, but using instead images of Western folk heroes. There would be sweeping scenes of Native life on the American plains, complete with buffalo, wigwams, horses, and eagles.

Feather armbands also became popular as tattoo designs, the best of them looking so realistic that the effect is almost *trompe l'oeil*. A similar effect can be seen on page 68 (*bottom right*), where Hamish Halley's right nipple is decorated with a tattoo to make it look as if the nipple has been pierced with a thong, as in the famous sun-dance initiation ceremony of the Plains Indians.

The recent popularity of tribal tattooing has led many to adopt Aztec and Mayan designs from Central and South America, as well as using the traditional Native American symbols. Most of the latter – which are borrowed from the tribes of the Pacific Northwest such as the Haida, Kwakiutl, and Tinglit – are beautiful, graphic representations of animals and birds, like the bear, eagle, and killer whale. Although originally used to decorate houses, clothing, drums, and blankets, such designs translate well onto skin. By wearing these totem animals, we too can feel echoes of the magical power of the tattoos worn by our ancestors.

44

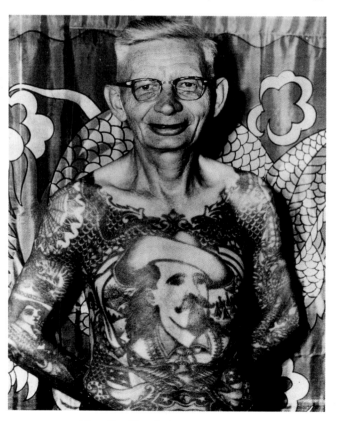

Above: Doc King displays his collection of early twentieth-century tattoos, including his Wild Bill Hickock portrait. Many of these tattoos were by Milt Zeiss of Illinois.

THE SKUSE COLLECTION

Opposite: Indian Chief's head tattoo on a member of the Bristol Tattoo Club, England, by Les Skuse. This is typical of the heavily black-outlined, stylized images that tattoo enthusiasts were choosing in the 1950s and 1960s.

THE SKUSE COLLECTION

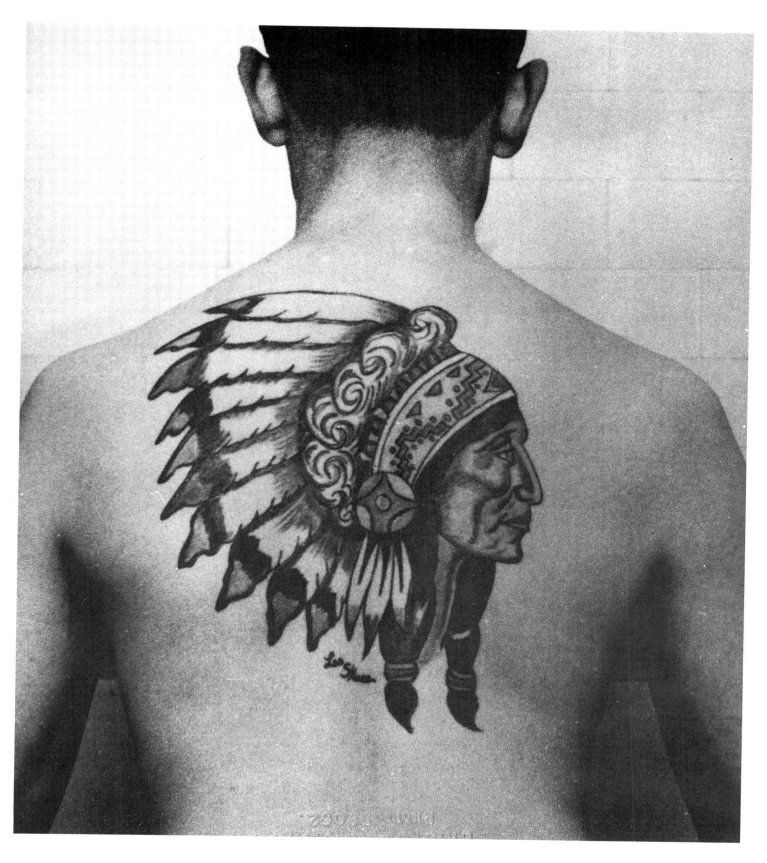

All pictures, this page and opposite: Dave Nelson of Reading, England, with extensive tattoo work by Ian of Reading, England.

I've been into Indians for a long time. I suppose I had an interest in the Wild West as a kid. Like hundreds of thousands of kids who grew up in the same era as I did. Wild West movies were a big thing, like space movies are today, but as I got older I started to read about what the real West was like and if you do that you invariably find out more about Indians. I became interested in them because they're a very special people. There isn't anyone else like them anywhere. You get very sad when you realise the terrible things that they've suffered – what they've gone through – and they're interesting, spiritual people. It was that kind of interest that led to my having tattoos involving them. After the first Indian's head on my forearm, I wanted something on the opposite forearm so I had Article 2 of the American Constitution (The Right to Bear Arms) done, which is nothing to do with Indians, but it's something I feel strongly about. After the two forearms, I had the rattlesnake done, which I suppose has got sort of tenuous connections with the Wild West. I got another Indian on my upper left arm and then I went to the other side and had an eagle. That turned into a shoulder cap, so then we extended the Indian's head on the left shoulder to include the village

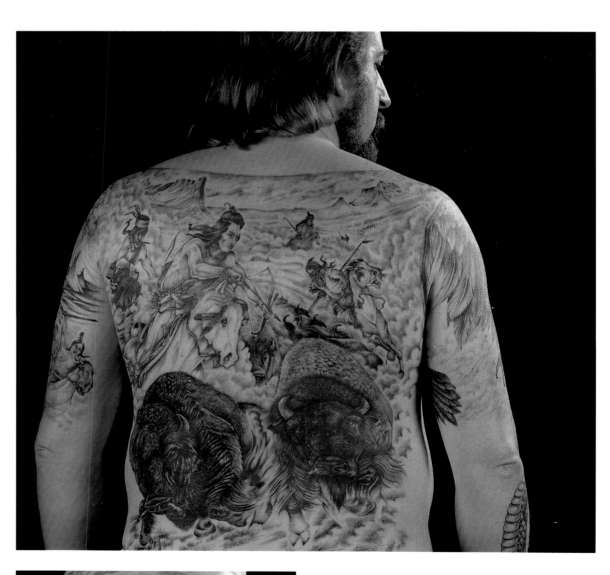

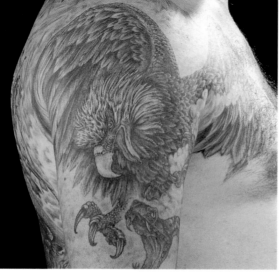

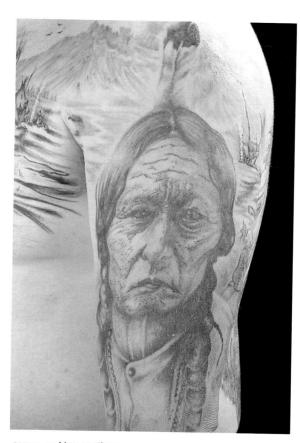

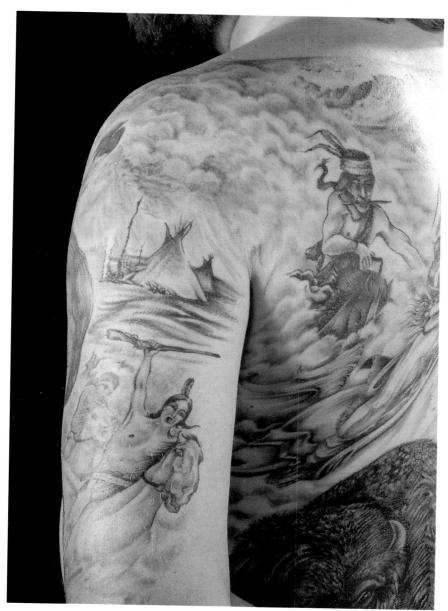

47

scene, making another shoulder cap.

I thought about the back piece for a long time and, with all the other things I've got, I thought the only really sensible thing was to have an Indian scene, and the buffalo hunt was one that I liked. The original idea is based on a painting. I think it's by Charles Russell, one of the contemporary artists who was there in the '80s. (10)

HENRY FERGUSON

"Both the archaeological record and the results of ethnological research show that virtually all the inhabitants of Precolombian America painted or tattooed their bodies – for a variety of reasons, though not, as a rule, simply to decorate their bare skin." Ferdinand Anton (11)

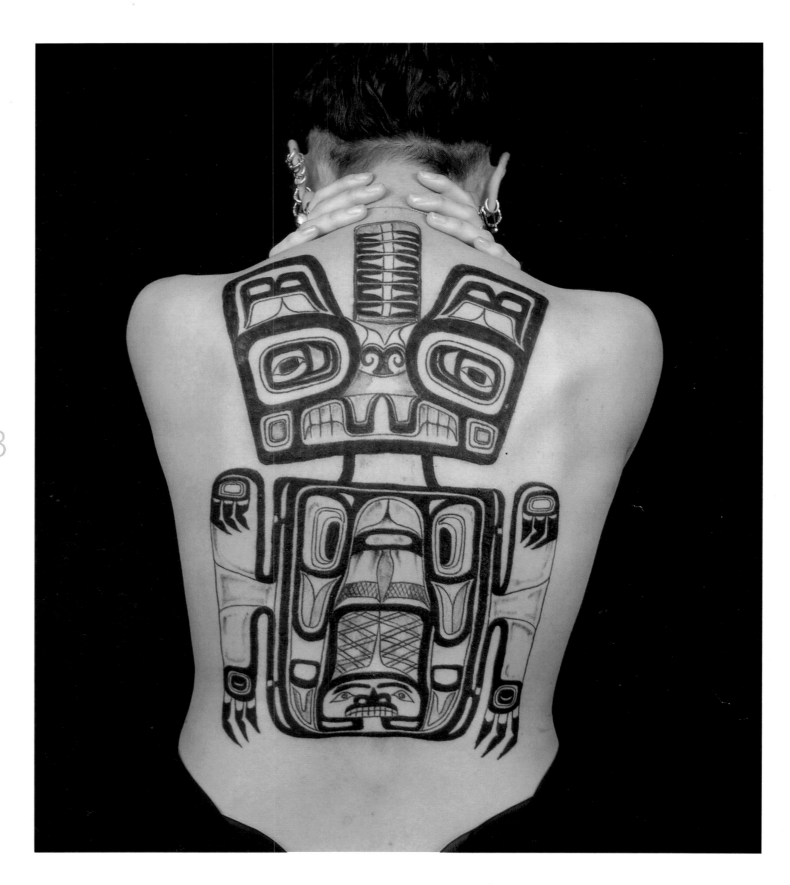

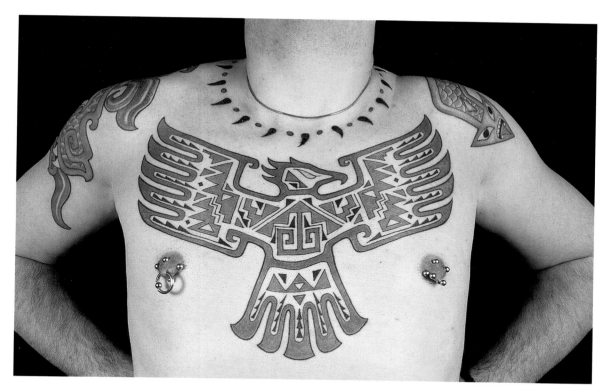

Left: John Sharpe's chest tattoo of an eagle is based upon the designs of several different North-American tribes, and his necklace is of stylized eagle claws. The dragon tattoo over his back and shoulders is based on Aztec designs. All tattoos are by Alex Binnie.

JAMES DRURY

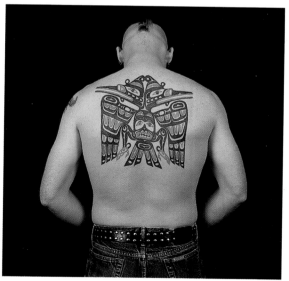

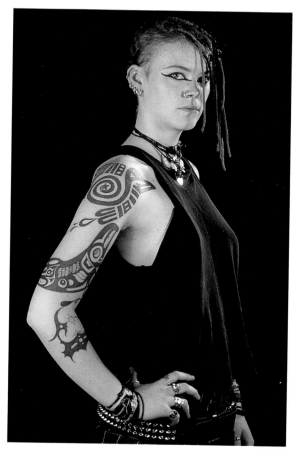

Left: Lene Nielsen's shoulder tattoo of a Mayan (Central America/Mexico) Indian bird leads down to stylized feathers, a Kwakiutl (Northwest United States) whale, and a small cover-up. All tattoos are by Erik Reime of Copenhagen, Denmark.

JAMES DRURY

49

Opposite and Above:
Two designs in the style of the Haida and Tinglit Native Indians of the American northwestern coast. Michelle (opposite) has a bear by Carl Turcott, and Jeremy (above) has a two-headed bird by Bob Paulin.

JAN SEEGER

celtic
european cultural roots

Exploration of the traditions of other societies through tattooing in the tribal and Native-American styles has led many Europeans to re-examine their own tribal pasts and cultural "roots" as potential sources of tattoo inspiration. For Northern Europeans, it was obvious to look to the Celts, the tribes who dominated the area before the Roman invasion and colonization. Not only were the Celts (like the Native Americans) indigenous tribes who were driven out of their homelands by a more technologically advanced conquering civilization (the Roman Empire), but they were also notoriously fearsome warriors who shocked the Romans by fighting naked. They also had skin decorations.

There is substantial evidence for this. In the first century B.C., Herodian described the Celts' body markings:

They mark their bodies with various figures of all kinds of animals and wear no clothes for fear of concealing these figures. (12)

There were tribes in northern Britain named Pict and Prytani, meaning that they were covered in pictures or painted. The Romans were impressed by these body decorations. In 55 B.C., Julius Caesar wrote about these tribes in *The Gallic Wars*:

All the Britons dye their bodies with woad, which achieves a blue color, and shave the whole of their bodies except the head and the upper lip. (13)

Some modern experts believe that Caesar was mistaken in that the blue color he described was due not to the use of woad (a blue plant-based dye in use on clothing at that time) but either to copper-based pigments that were painted onto the body, or to black tattoos that, like so many twentieth-century black tattoos, had turned blue over the years.

Although no examples have yet been found of preserved tattooed Celtic bodies, occasional examples of bodies from this period featuring tattoos have been found elsewhere in Europe.

Designs for the majority of today's Celtic-style tattoos are based on the interlocking knotwork style of decoration as used by monks to illustrate *The Book of Kells* – the elaborately embellished Latin text of gospels, thought to have been written and illustrated in monasteries in Scotland and Ireland between the seventh and ninth centuries. The knotwork style is also often seen carved into stone monuments, such as Celtic crosses. Such designs, executed either as simple blackwork, elaborated with other colors, or incorporated with other motifs, have become particularly popular in the original Celtic homelands of Northern Europe. Some of the most intricate examples have been produced by English tattoo artists such as Mickey Sharpz and the late Mr Sebastian, and the Dutch artist Ronald Bonkerk.

Above: Detail of a Celtic-sun shoulder tattoo with interlock-style armband belonging to Joe Corcos of Manchester, England, by Micky Sharpz of Birmingham, England.

HENRY FERGUSON

Opposite: Celtic interlock-style shoulder piece, by Ronald Bonkerk of the Netherlands.

JAMES DRURY

50

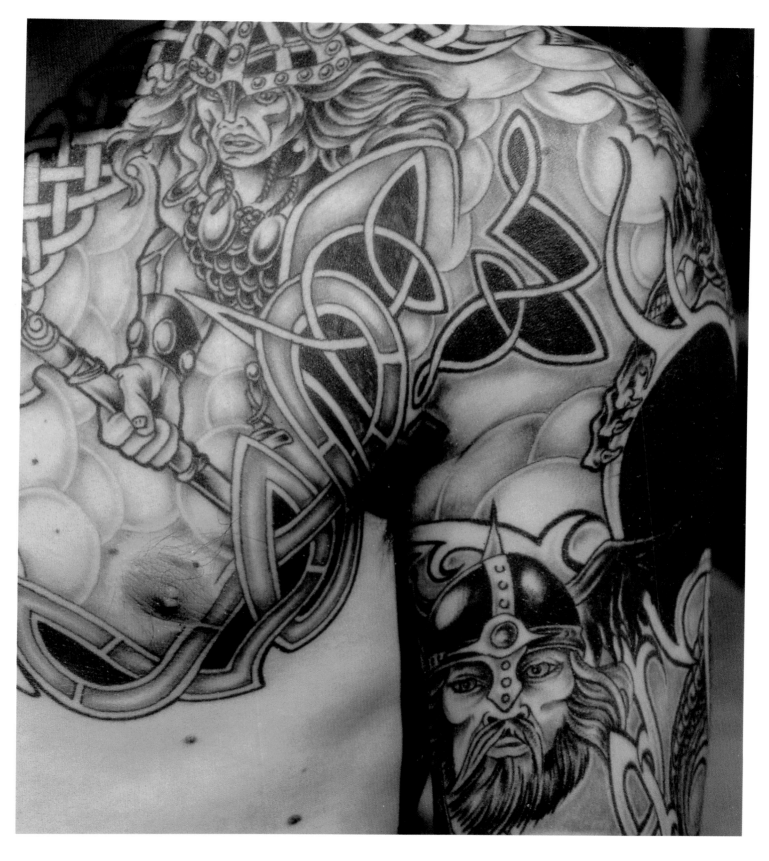

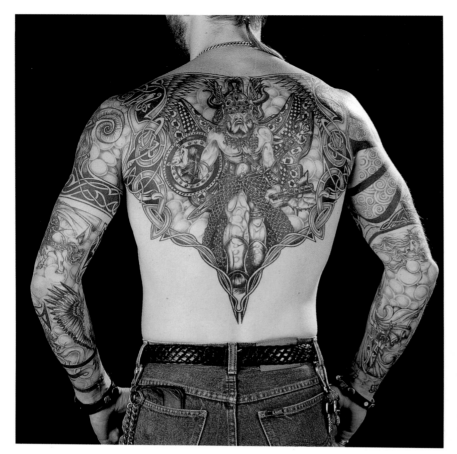

Left and Below: Eus displays his beautifully executed and extremely complicated tattoo by Ronald Bonkerk. Interlock patterns are integrated with images of warriors and Celtic beasts. In this back, shoulder, and arm tattoo the spaces left untattooed are vital in defining the overall shape.

HENRY FERGUSON

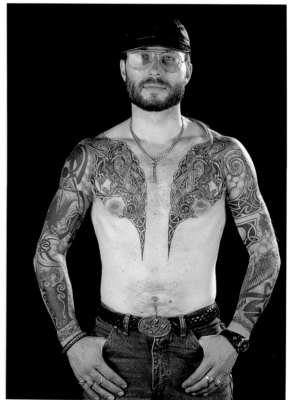

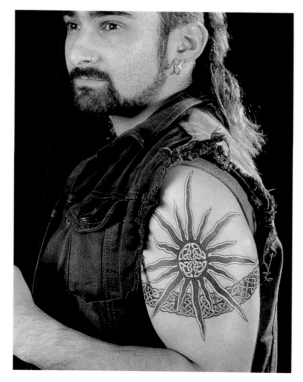

Left: Joe Corcos of Manchester, England, with his Celtic-sun shoulder tattoo with interlock-style armband by Micky Sharpz of Birmingham, England.

HENRY FERGUSON

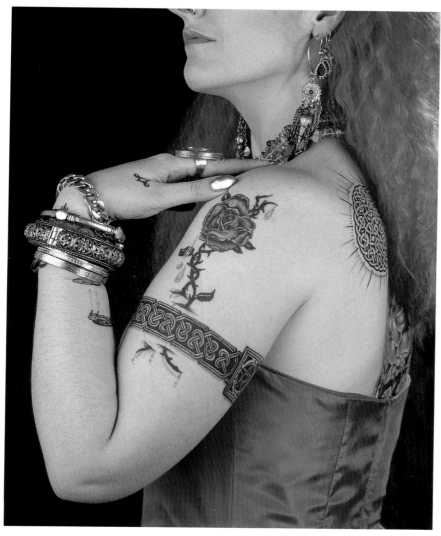

Above: Yvonne Neville's pastel armband tattoo by Micky Sharpz shows how effectively color, which was used to wonderfully subtle effect in *The Book of Kells*, can be incorporated into Celtic interlock patterns.

HENRY FERGUSON

Above: Joolz, poet and performer. The Celtic sun on the back of her shoulder is symbolic of the eternal interweaving of life, death, and the universe. The rose symbolizes England's growth from its Celtic roots, represented by the armband. The rose weeps for "the state of the country under the Conservative government." All Joolz' tattoos are by Micky Sharpz.

HENRY FERGUSON

Left: Design of interlocked "beard pullers" taken from *The Book of Kells*, the illuminated manuscript that is thought to have been illustrated by the monks of Iona, Scotland, and Kells, County Meath, Ireland, between the seventh and ninth centuries. This manuscript is a major influence upon current interest in the Celtic style. Tattoo drawn by Wally Poulton of Southminster, England.

HENRY FERGUSON

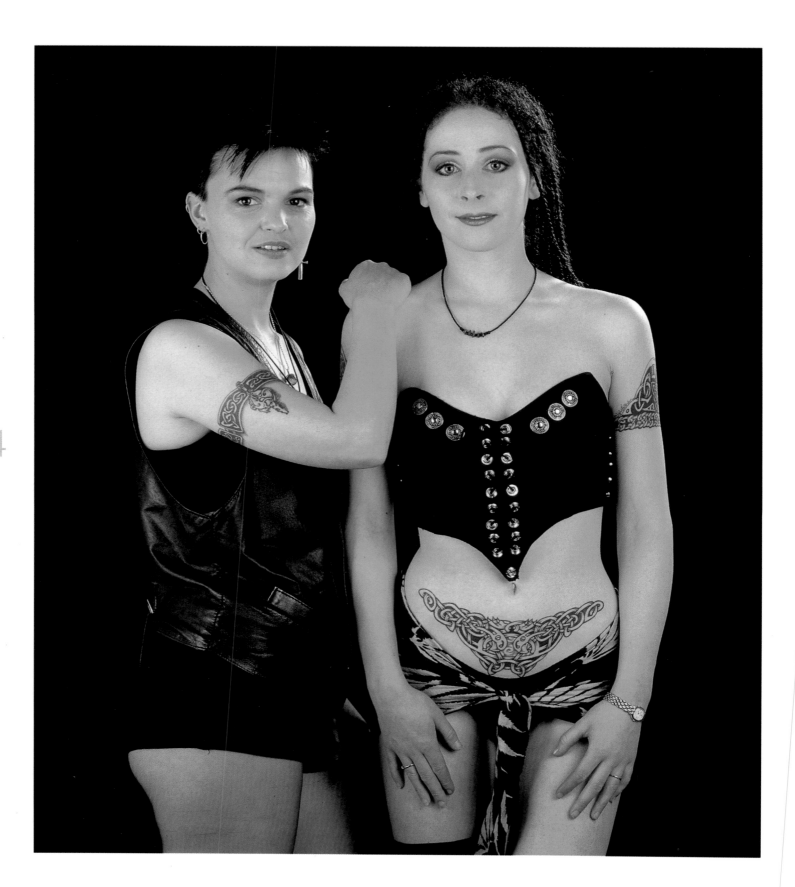

54

Opposite: Janis Caldwell *(on the left)* of Newtown Abbey, Northern Ireland, and Grainne Kelly *(on the right)* of Belfast, Northern Ireland, sport their Celtic interlock tattoos by Skull and Dark of Belfast, Northern Ireland.

HENRY FERGUSON

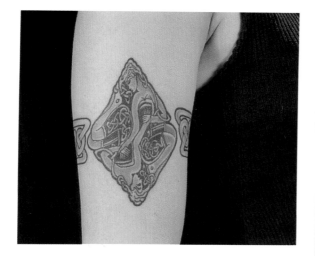

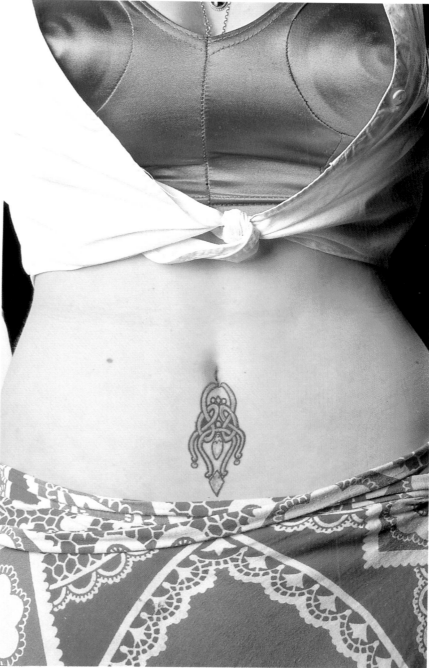

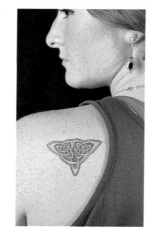

Above and Right: Mia Cleaver of Birmingham, England, has a Celtic armband tattoo with interlocked figures. Tess Corcos of Manchester, England, has a Celtic triangular knot. Both tattoos are by Micky Sharpz: **I'd seen a lot of design motifs, read quite a lot about it and found Celtic art an interesting subject anyway. Using the designs in tattooing came as a slow natural process. I started to do small amounts of it and realised how complex and precise it is you're working a line which has got to follow a certain set pattern, there's no freedom, no room for error. (14)**

HENRY FERGUSON

Above: The belly dancer's brooch was tattooed on Nellie of Chesterfield by John Sargerson and was inspired by Celtic knotwork designs.

HENRY FERGUSON

blackwork
beauty in simplicity

The success and popularity of all-black tattoo designs, whether in the tribal, Native-American, or Celtic styles, has led to the creation of a wide variety of monochromatic tattoo work in all sorts of styles in the West today.

Traditional Western tattooing has often been criticized for being messy and ill-defined compared with Japanese or tribal work; critics claim that the body can end up looking more like a scrap-book collection of unrelated images than a unified work of art. This can be particularly true when the tattoos are old, blurred, and faded by the sun.

The tendency for tattoos to fade is largely determined by the skill of the tattoo artist applying the ink. Inexperienced (or bad) tattooists often apply ink too shallowly, in which case the tattoo fades as the skin naturally renews itself. Or they apply the ink too deeply, in which case the lines spread as the ink disperses itself into the layers of fat beneath the skin. Either way, the tattoo will be blurred and/or patchy. Modern colors should stay true much longer than those old inks, but only time will tell.

Blackwork can be considered to have the following advantages over work that utilizes color: because black tattoo pigment is the least susceptible to fading, the tattoo should look good for longer; because black "goes with everything," tattoos done at different times or by different artists should complement each other; and because black goes over any other color, it is very useful for covering any unwanted tattoo.

Good blackwork is, in fact, particularly difficult to do because it requires great skill to apply black ink uniformly over large areas, provide all the nuances of subtle shading, and ensure that the lines are absolutely right. (A patchy tattoo or one with shaky lines and wobbly curves can be very ugly.) When it is done by an expert, a blackwork tattoo can be astonishingly beautiful – and if one only ever wears black, or if a person's favorite garment is a black leather jacket or a little black dress, a good blackwork tattoo is the obvious choice.

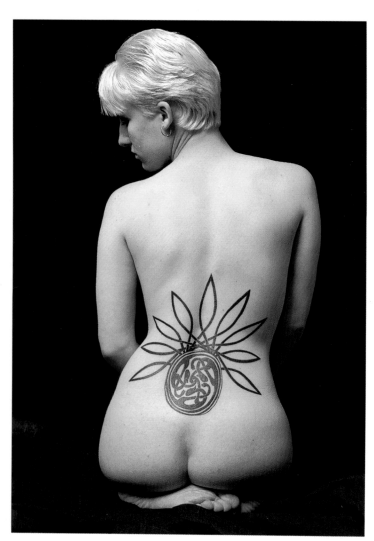

Above: Lower back design by Mad Jack on Catherine of Chicago, Illinois.

WILLIAM DEMICHELE

Opposite: Chuck's beautiful back piece by Trevor Marshall combines influences from around the world into an integrated blackwork design.

JAN SEEGER

56

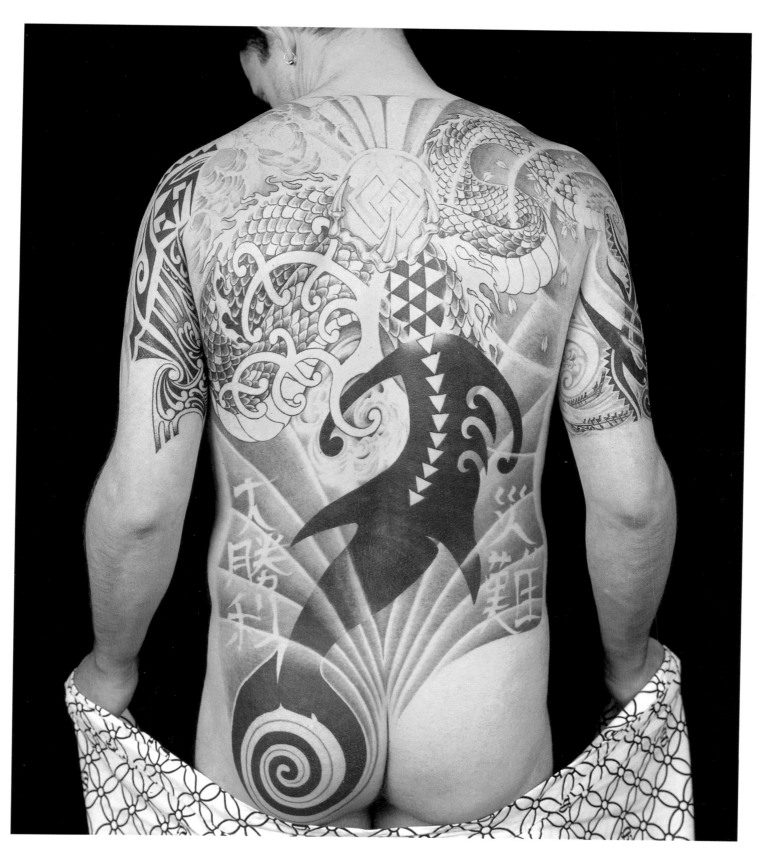

Right: A number of very different designs by Dick Want of D.K. Designs, Gillingham, England, are more easily integrated into an overall composition because they are monochromatic. Dick performed these tattoos on himself.

HENRY FERGUSON

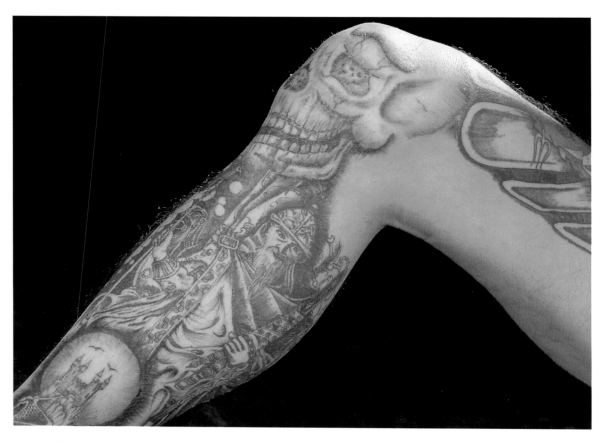

58

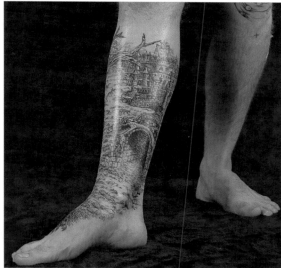

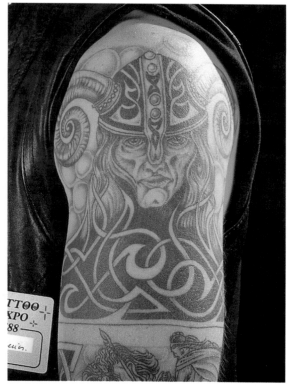

Above: If the skin is particularly hairy, it is usually shaved before being tattooed. Many entrants in tattoo competitions also like to shave and oil their skin in order to make their tattoos appear sharper, although the reflections this causes also makes them more difficult to photograph. The landscape on Daniel Collins' calf is by Terry Scott.

HENRY FERGUSON

Left: Detail of one of the shoulder pieces of the upper-body tattoo performed on Eus by Ronald Bonkerk; the entire tattoo is shown on page 52.

HENRY FERGUSON

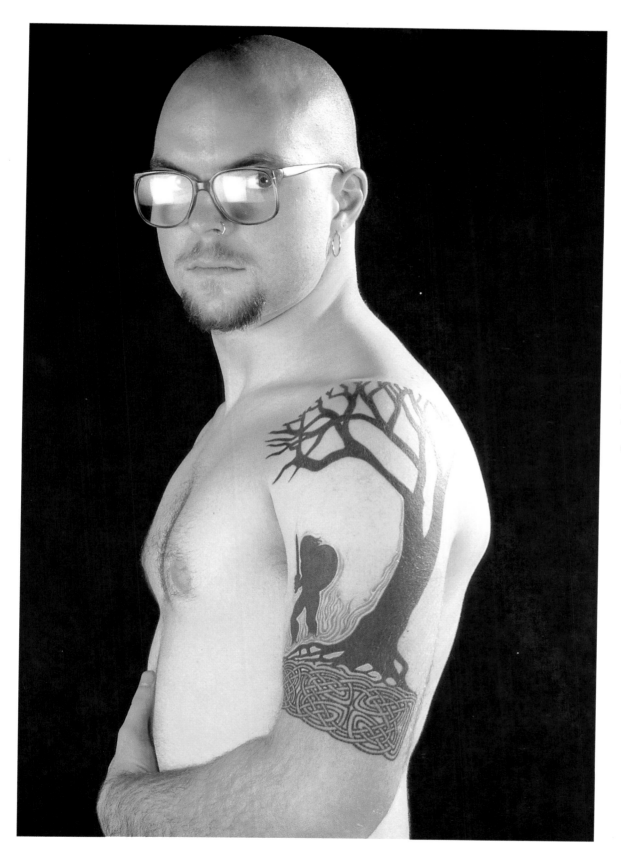

Left: Ged Forrest of Bradford, England, boasts a tattoo by Micky Sharpz that incorporates a Celtic interlock armband with striking monochrome imagery: **Really, it's much more graphic than the standard type of tattoo. It's a totally different thing. You've got to concentrate a lot on what you're doing; you've got to work the lines A to B and they've got to be even and black. Looking at it against skin, the contrast between the black and white is much more interesting than the usual shading and color. Although that works to a certain degree with a certain type of tattoo, Celtic and other tribal style designs look so clean and neat. (15)**

HENRY FERGUSON

Right: Blackwork can be used to integrate many different images and/or styles into one coherent tattoo or, as in these designs by Alex Binnie on Brian of California, it can be used in a minimalistic way to produce an effect that is very different from our usual ideas about what it means to be tattooed:

Most of the ideas and designs I'm working with come from ancient art traditions from around the world. Indonesian, Mayan, Persian, American Indian, Celtic – the list is endless. I don't invent new forms but play with old ones. A Tibetan cloud, an Aztec face, a Japanese flame and a Mayan spiral; mix them together and who knows? Anything is possible, there are no rules in design except aesthetic ones. If it looks right, it is right. (16)

JAN SEEGER

60

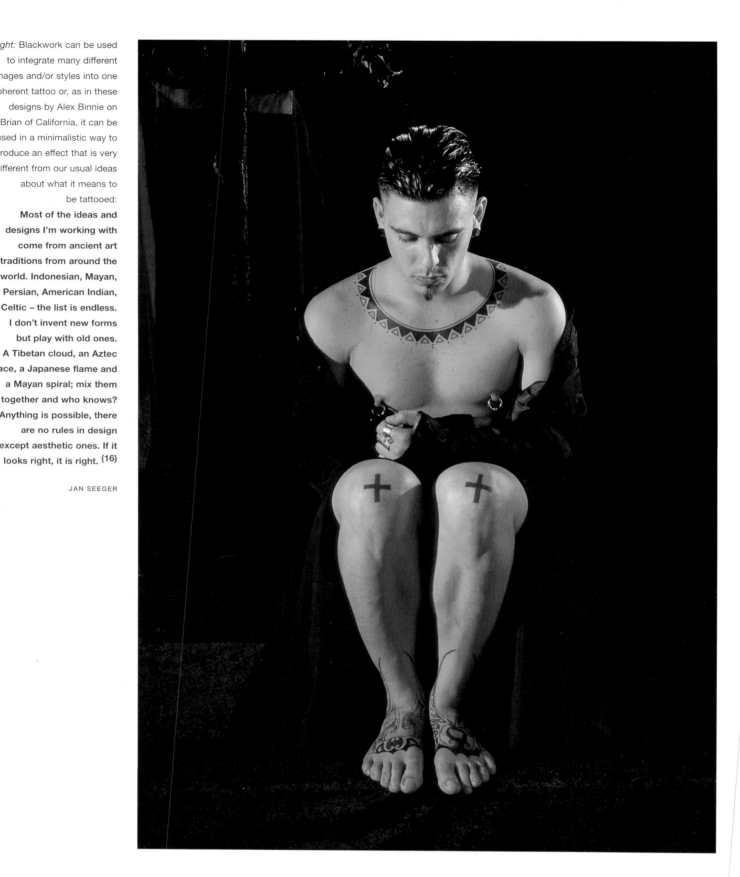

Right: Victor Whitmil's piece combines tribal-style abstract lines with realistic monochrome orchids. The wearer, Carla, was photographed in Texas.

JAN SEEGER

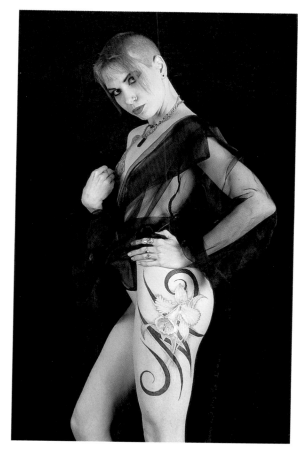

61

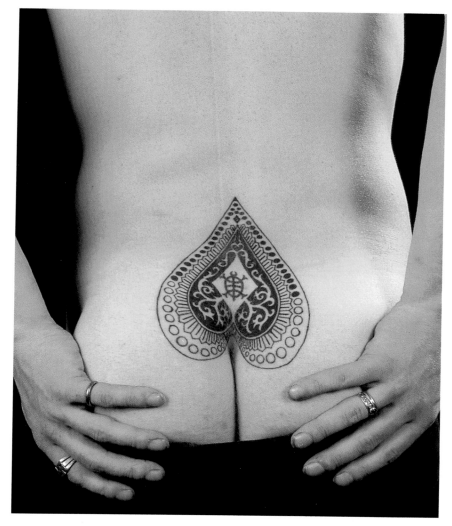

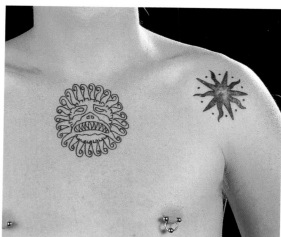

Above, left and right: Ian Lester of Brighton, England, sports a selection of blackwork designs inspired by other cultures.

JAMES DRURY

Right: An unusual armband of dancing men tattooed on Irene of Lewisa, Virginia, by Matt Woodham.

WILLIAM DEMICHELE

62

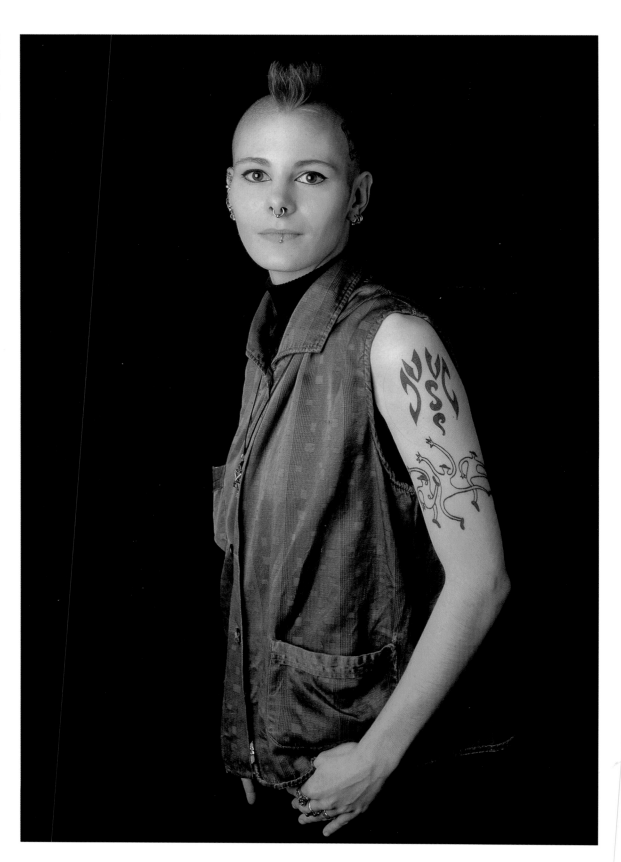

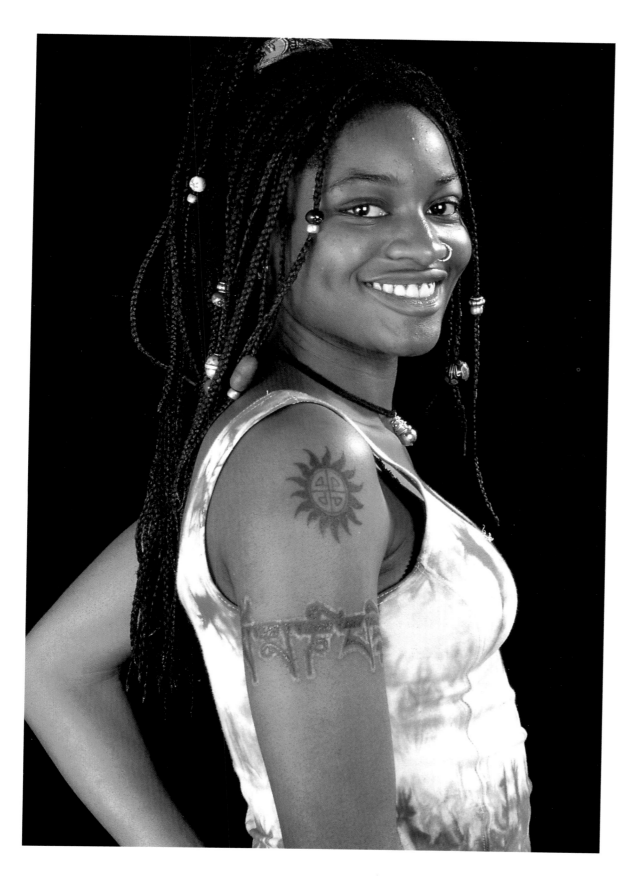

Left: Rudy Dibosa's Celtic-sun tattoo is by Phil of Northamptonshire, England; her armband is by Xed le Head of London. People with very dark skin have traditionally used scarification instead of tattooing because black-ink designs do not show up clearly against very dark skin. The use of white pigment in this tattoo effectively outlines the black armband.

HENRY FERGUSON

Right: Barbara's tattoo, by Trevor Marshall, displays many of the elements of Japanese tattooing: the single integrated design covering much of the body, the flowing waves, and the subtle, watery shading. Its strong, graphic shapes and lack of color, however, also show a strong tribal influence.

JAN SEEGER

64

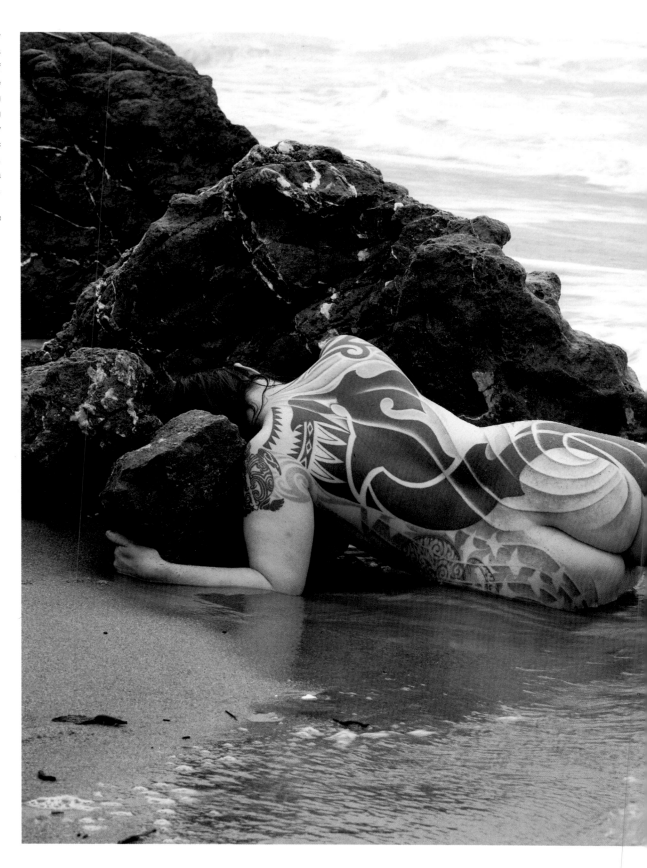

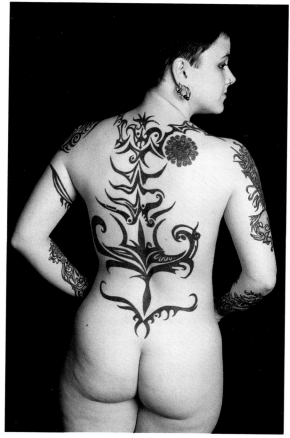

65

Above: Raya from Chicago, Illinois, displays her David Kotker tattoo. Kotker of "No Hope No Fear," Chicago, is one of the modern tattooists who formerly were artists, in his case a successful professional sculptor. He decided that he wanted more contact with the people commissioning his work and so became a tattooist.

WILLIAM DEMICHELE

"For the inhabitants of Mentawai, an archipelago in the far west of Indonesia The purpose of tattooing – like the sharpening of the incisor teeth at puberty – is to lend the body 'dignity', because a person's soul would not feel at home in a body that was not artistically 'completed' with fine drawings."

Professor Dr Reimar Schefold [17]

badges
of allegiance

In most tribal cultures worldwide, permanent body decorations such as tattoos perform a social function: they mark an individual as a member of his or her society. This is also the case in Western society, despite the huge variety of tattoos available.

This is clearest when one looks at the traditional tattoos collected by sailors on their travels. Not only were they souvenirs of foreign lands, the tattoos were also badges that proved that the wearer belonged to the world of sailors – men who had to depend on each other for their very survival, for at sea there was no one else (other than God) to turn to. Soldiers, too, were regular customers at the tattoo studios that set up business in garrison towns, sealing their comradeship with tattoos celebrating their service to their country or their membership of their fighting unit.

If an individual wishes to proclaim that his or her allegiance to a club, gang, or similar peer group is more important than the opinion of society at large, and if that person wants this situation to continue forever, a tattoo is the ideal medium to carry the message. In some cases such tattoo "badges of belonging" are publicly displayed and easy to read. Examples include those seen on punks, gang members, and bands of "outlaw" bikers.

. . . in spite of growing acceptance, tattooing retains traces of transgression. For many people, tattoos are still badges of protest or rebellion that are worn with deviant pride. (18)

Yet, if one thinks about it carefully, one realizes that – despite our generally seeing the act of getting tattooed as being one of the strongest ways of asserting individuality and rejecting social norms and conventions – a tattoo must always reflect who you are (or were at that time), and where you were in social time and space. And that is always the case – whether you spent months carefully considering and planning your tattoo, or whether you simply walked into a tattoo parlor and chose a design from the sheets of flash on the wall.

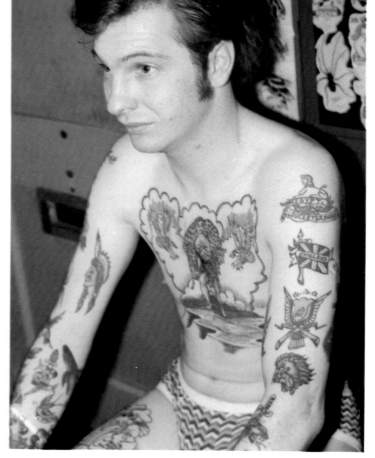

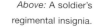

Above: A soldier's regimental insignia.

THE SKUSE COLLECTION

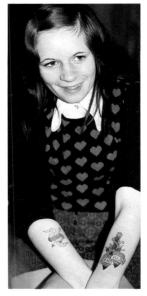

Left: Gilbert's back tattoo of Christ's Resurrection clearly proclaims his Christian faith. The tattoo was done in the 1940s by Les Skuse and captures the "feel" of a stained glass window in an English church.

THE SKUSE COLLECTION

67

Above: This girl must hope that her relationship will last as long as her tattoo of entwined hearts and name scrolls. Dating from the 1970s, this tattoo is by Denis Cockell.

THE SKUSE COLLECTION

Opposite, bottom left: Version of the old Player's Navy Cut cigarette logo reworked by Saz Saunders of Warrington, England, to incorporate the names of Rambo of Manchester's sons.

HENRY FERGUSON

Opposite, bottom right: American eagle logo which can only refer to Harley-Davidson motor cycles, by Dave Ross of Colchester, England.

DAVE ROSS

Left: Many couples like to mark the permanence of their relationship with matching Celtic wedding-ring tattoos, such as this one on Mia Cleaver by Micky Sharpz.

HENRY FERGUSON

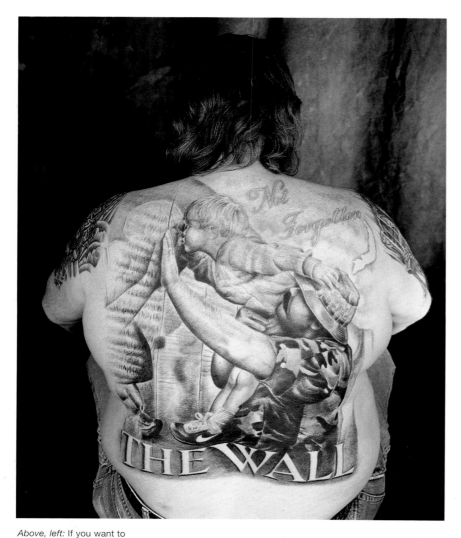

Above, left: If you want to show the world what is important to you, there is no more permanent or obvious way of doing so than via a major piece of tattooing. The Wall, tattooed on Jack by St. Marq, commemorates all those Vietnam veterans who died and will not be forgotten.

Above, right: Jack Daniel's, pool, and *Easy Rider*, tattooed on Jean by Antoine Miguens, encapsulate one type of biker lifestyle.

JAN SEEGER

Left: This cartoon character Weetabix Kid, photographed in London in the early 1980s, is a Skinhead emblem which can be displayed or hidden as its wearer chooses.

HENRY FERGUSON

Above: Sometimes tattoos can symbolize relationships in ways that are not obvious to others. The identical spears that both Hamish and his wife Tanya have tattooed under their right arms only read as symbols of their relationship when seen together. The tattoos are by Ian of Reading, England.

HENRY FERGUSON

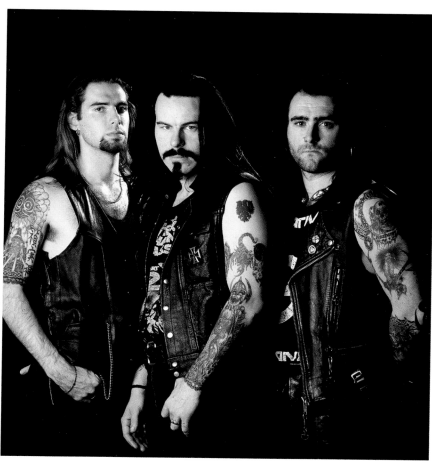

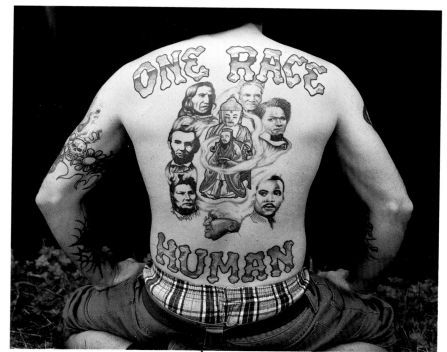

Above: Carl Honeybone's bike-riding demon with its "freedom" flag embodies the philosophy of "Too fast to live, too young to die." The tattoo is by Ian of Reading, England.

HENRY FERGUSON

Above: A. Corcoran and Paul Finnan of Birkenhead, and Rich Clarke of Liverpool, England. For very many people, in many different societies and situations, their tattoos are an inherent part of their overall aesthetic. All tattoos by Pete Colwell of Birkenhead, Merseyside, England.

HENRY FERGUSON

Left: A selection of humanitarian heroes tattooed by Thomas DePriest. The human body provides a powerful billboard for any message.

JAN SEEGER

humor and cartoons

For many people getting tattooed is such a momentous personal milestone that it can only be treated with the utmost seriousness. For others it provides numerous opportunities for humor, although the gallows humor of the often-seen tattoo comprising a dotted line around the neck with the words "Cut Here" written below does not appeal to everyone.

Humorous tattoos have always been popular with sailors, soldiers, and other people who, by nature of their work, have to live together in cramped quarters, and who are therefore used to seeing each other naked or only partly clothed. Long-standing "in jokes" include being tattooed with the words "Admiralty Property," or having "Twin Screws" and "Keep Clear" written above matching pictures of a propeller on each of the wearer's buttocks.

If much locker-room humor can be sexual in nature, it can also often be sentimental, such as the scroll proclaiming, "The sweetest girl I ever kissed was another man's wife, My Mother." Most of it, however, spans the gap between the vulgar and the totally obscene. One classic example features two eyes tattooed onto the buttocks where they can be viewed when their owner bends over, with or without the words, "I can see you," tattooed above them. More unusual is the cartoon Popeye tattooed over a man's pubic area, providing that particular spinach-eating sailor with genitals even bigger than his muscles.

Cartoon characters of all sorts lend themselves well to use in tattoos. Betty Boop, Mickey Mouse, Bugs Bunny, Fred Flintstone, and the rest

have all regularly appeared on skin in the past in the cause of raising a smile. Modern comic-book heroes and heroines continue to prove popular.

Much of today's tattoo humor is more subtle and sophisticated than the locker-room jokes of yesteryear, so it is worth looking carefully at the tattoo work around you. It is surprising how often jokes are revealed – for example, the traditional-style dagger and scroll tattoo worn by a pretty young woman which, on close examination, turns out to read not "Death before Dishonor," but "Death before Dishwashing."

Above: Two soldiers display the "eyes" tattooed onto their eyelids – presumably the idea was to make it appear that they were paying attention when they were in fact asleep.

THE SKUSE COLLECTION

70

71

Above: The idea of showing flames issuing from between a man's buttocks is a popular visual joke. In this version by legendary Hong Kong tattoo artist Pinky Yun, the devil stokes the flames while an angel attempts to douse them with a fire hose.

THE SKUSE COLLECTION

Left: The cartoon-character cowgirl and hoola girl tattooed on Danise of Chicago, Illinois, by Scott Harrison are affectionate recreations of the pinup girls that were traditionally so popular with sailors.

WILLIAM DEMICHELE

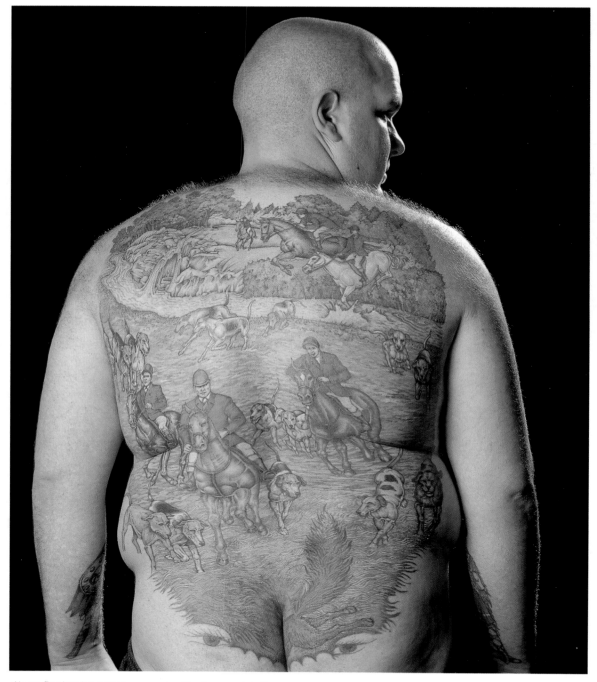

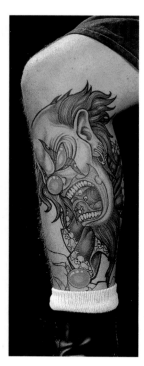

Above: Another image with a modern twist – the clown's humor is very black indeed in this version by Ron Earhart, performed on himself and photographed in California.

JAN SEEGER

Above: Fox-hunting scenes were once popular images of rural life which have, at various times, adorned everything from oil paintings to suburban table mats. This highly respectable image was given a wry twist when used as a tattoo back piece in which the fox was about to disappear into the only available cover. This is a colorful modern version, on Tony Harvey of Bognor Regis, England, by Graham Townsend, of a tattoo that dates back to Victorian times.

HENRY FERGUSON

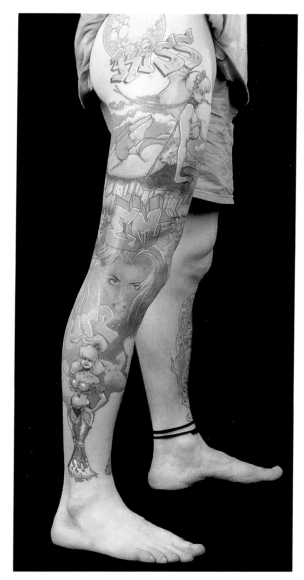

Above: Contemporary cartoon heroines provide the inspiration for this colorful leg tattoo on Kevin Teague of Devon, England, by Jim Ryan.

HENRY FERGUSON

Below: Amusing and well-observed animal characters populate this back piece on Anne Kuski, tattooed by Harry Potter.

HENRY FERGUSON

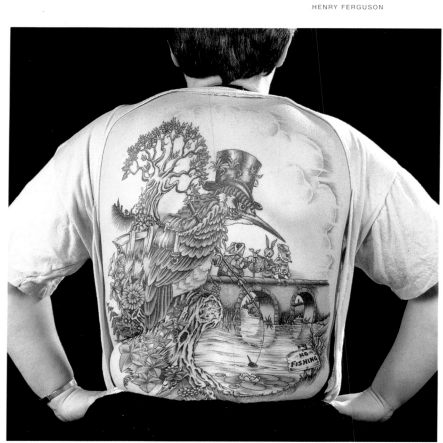

73

Left: Mock wound design on Hamish Halley by Ian of Reading, England:

My bizarre sense of humor has transferred into some of my tattoo work. I am fascinated with wounds and the way they heal, and also with tools and weapons that are designed to part the flesh My wounds include a Great White Shark bite worked around my shark tattoo. The back part of the tattoo is bootlace style stitches with a 4 gauge needle imbedded behind the knee. The stitches were from a Napalm Death album cover. (19)

HENRY FERGUSON

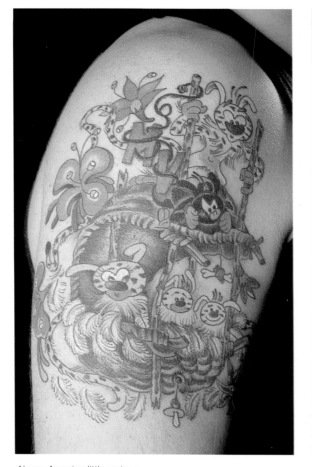

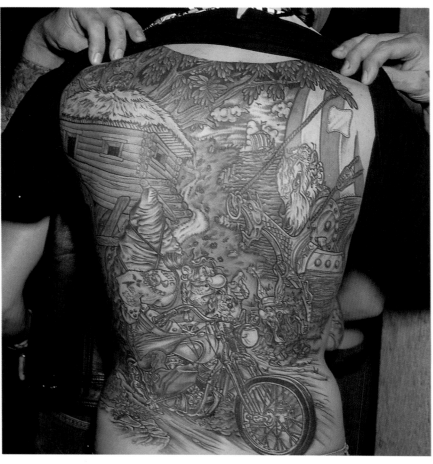

74

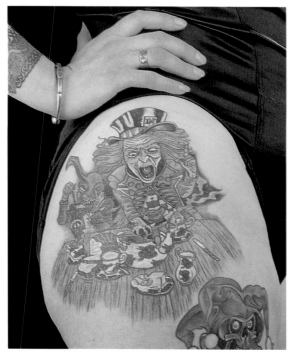

Above: Amusing little cartoon animals, tattooed on Mike Vose of Germany by Monique of Wiesbaden, Germany.

HENRY FERGUSON

Left: Mad Hatter design on Tracy Wellings by Alan Dean of Luton, England.

HENRY FERGUSON

Above: Asterix the Gaul and his sidekick Obelix are here updated, on Willem, as bikers by tattooist Ronald Bonkerk of Holland. There are many witty touches, particularly in Obelix's "Celtic Brotherhood" tattoo, earring, and studded wristband. Photograph taken in Nijmegen, Holland.

ROB WEBSTER

Opposite: This cartoon-inspired shoulder tattoo on Lesley of Columbus, Ohio, is a work in progress by Guy Aitchison. (The Celtic bracelet on the wrist is by Curb.)

WILLIAM DEMICHELE

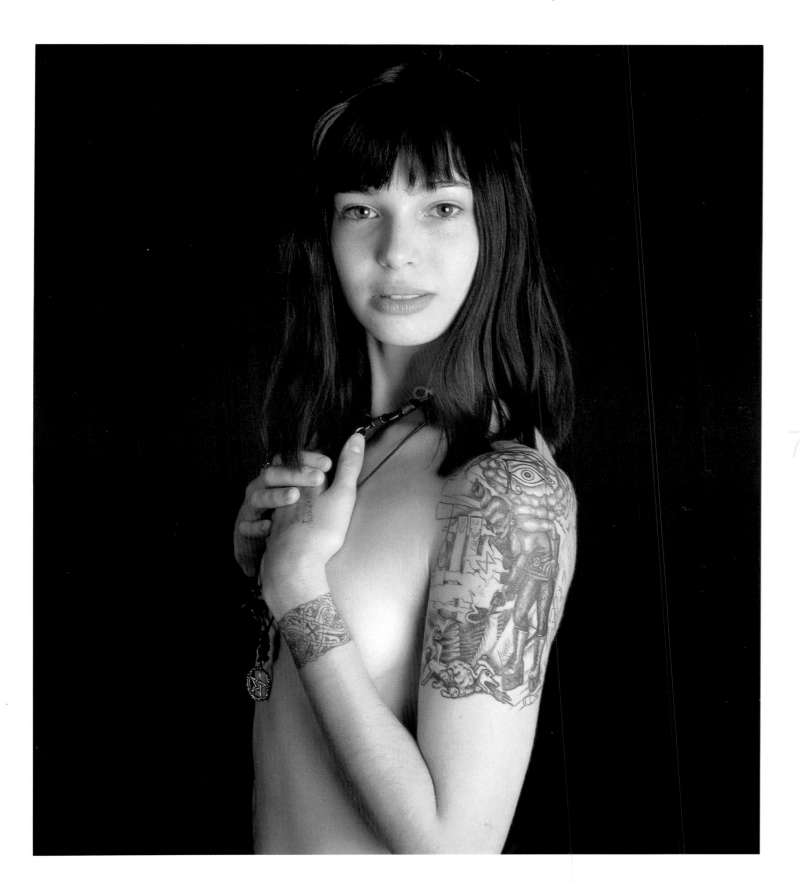

death and horror

Looking back through old tattoo photographs and drawings, it is fascinating to see that, although the tattoo designs of the past regularly included items such as devils and daggers, these were comparatively minor elements, rather than the central subject. In traditional Western tattooing the most powerful image of death was that of Christ crucified, soon to rise again – a world away from what is probably the single most popular tattooed image of today, the all-pervasive grinning skull!

Perhaps death was too close to the soldiers and sailors of the early twentieth century for them to want to adorn themselves with dancing skeletons, meticulous graveyard scenes straight out of Dracula, livid Frankenstein monsters, and flesh-eating monsters from hell. Perhaps they simply accepted death's inevitability more easily than we do today. Or perhaps the horror genre was just not as popular then.

The rise in popularity of the image of the not-completely-dead started before *The Mask*, before Megadeath, before The Grateful Dead. Today images of horror and death are all around us: from posters for innumerable horror movies; from the images used by heavy-metal bands and other rock musicians; from comic books; and elsewhere. We are surrounded by skulls and skeletons, vampires and zombies,

ghouls and grim reapers. Bikers and heavy-metal fans wear skull rings; children dress up as witches, ghosts, and skeletons for Halloween; and at tattoo conventions one can buy made-to-measure vampire teeth, together with all the bits and pieces one needs to redecorate the home as Dracula's castle:

The world of tattooing is strongly imbued with traditional representations of life, death, and the hope of afterlife. Skulls imprinted on skin abound, and depictions of the Grim Reaper are commonly seen These images, indelibly marked on skin, function as symbols that reflect uncertainty about the future, and sublimate the pervasive fear of the unknown. Possibly, at the same time, to wear a death's figure on one's own body may be an invocation of whatever undefinable forces of nature and the cosmos that exist, in an attempt to protect the wearer from such a fate. [20]

Seen from that perspective, it is not surprising that so many contemporary tattooed images of death and horror are outstandingly beautiful, colorful, vibrant – and full of life and humor.

Above: Skulls within skulls, tattooed on Dave Taylor by Dave How of Crawley, England.

HENRY FERGUSON

Opposite: A lively skull stares out from this back piece tattooed on Mike Bozz of Neuchatel, Switzerland, by Filip Leu of Switzerland. The design is particularly clever as the image is enhanced, rather than distorted, as the back moves, bends, and changes position. Photograph made in Amsterdam.

JAMES DRURY

76

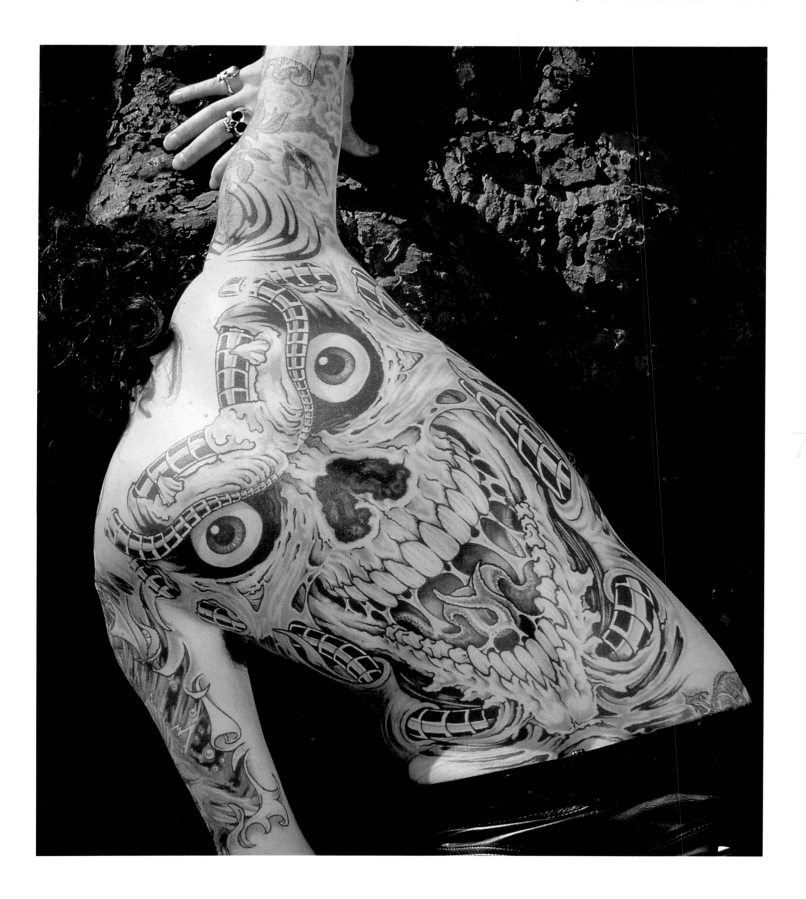

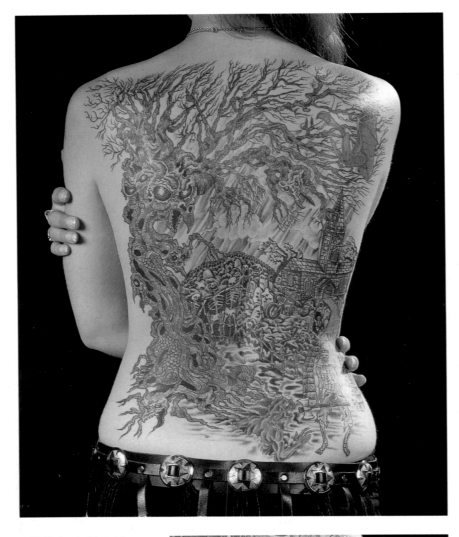

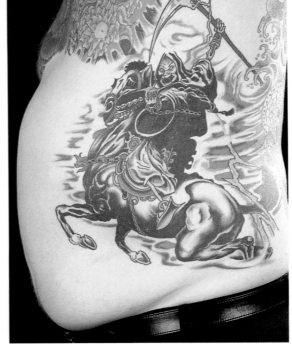

Left: An atmospheric graveyard scene on Helga by George Bone of London.

HENRY FERGUSON

Right: A colorful skeleton on Carl Honeybone by Ian of Reading, England – yet another image graphically portraying the frailty and mortality of the flesh upon which it is inscribed.

HENRY FERGUSON

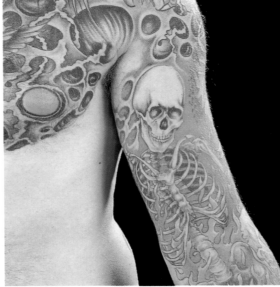

Above: A grim reaper on horseback design tattooed for E. Hedges by George Bone.

JAMES DRURY

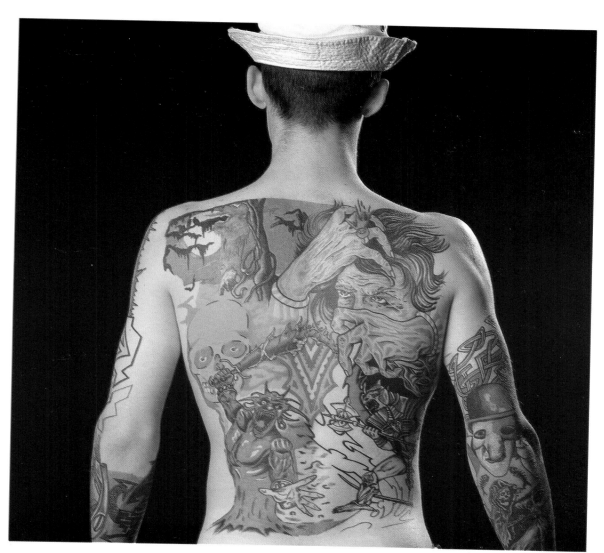

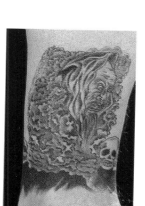

Left: A selection of horrific characters executed in glorious color on Neil Orange by Dave Ayres of Skin Deep Tattooing, Bristol, England.

HENRY FERGUSON

Right: Skulls depicting the evolution of man, tattooed by Darren Stares:
I found photos of the 'key' people, chronologically arranged them in a vertical pillar and Darren tattooed them in portrait style. This tattoo is really a death's head tattoo with a new twist to it. The skull hovering on top of the pile is the Armaggedon Machine 'Mark 13' from the film 'Hardware', an appropriate 8th man, I thought. (21)

HENRY FERGUSON

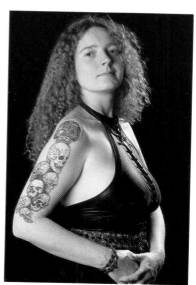

Above: Wizard and skulls ankle tattoo on Jack Yount of Florida, "where I had my name and social security number covered up" by Dennis Watkins, Fort Mead, Maryland.

HENRY FERGUSON

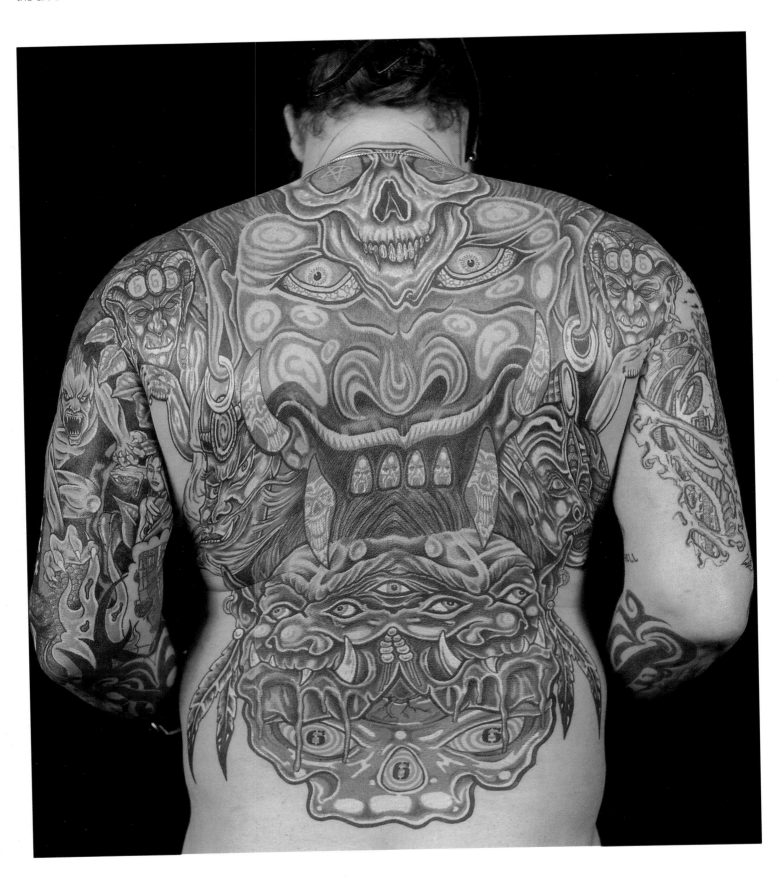

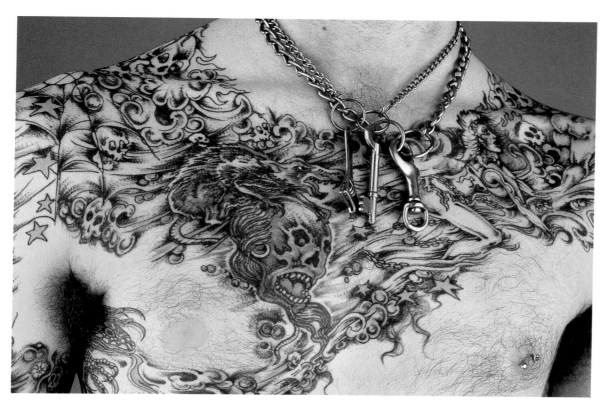

Left: Menacing blackwork skulls on S. Curtis by Dave Ross of Colchester, England.

HENRY FERGUSON

Below: Frankenstein's monster and friends as a back piece tattooed on Fritz by The Fatman, and photographed in Tennessee.

JAN SEEGER

Right: Detail of grimacing skulls that form a border around a Gorgon's head. Kenneth Hill was tattooed by Micky Sharpz of Birmingham, England.

HENRY FERGUSON

Opposite: Canadian nightmare – a colorful back piece of monstrous faces, eyes, fangs, and drooling mouths on Stéphane, by Reynald Mougenout.

JAN SEEGER

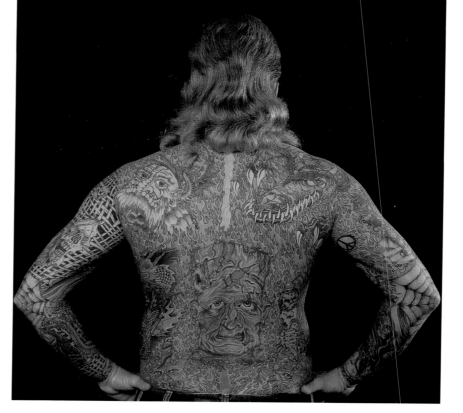

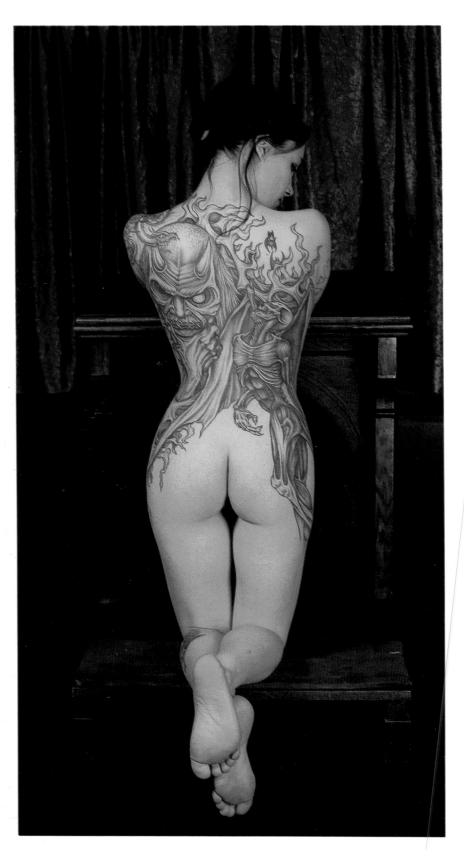

Right: Ghoulish design by
Paul Booth on Barbara,
photographed in New Jersey.

JAN SEEGER

"The symbology of death pervades all cultures, and is both graphically and subtly portrayed in art, verse, song, and via the complex funerary rituals that have developed to maintain a milieu of respect and reverence, as well as reinforce the hope of some sort of continued consciousness beyond the pale. By depicting a representation of death, whether as a skull, skeletal figure, or grim reaper, an attempt is made to sublimate the uncertainty of day-to-day existence. In the final analysis, the maintenance of the delicate spark that imparts the phenomenon we term 'life' is contingent upon constantly shifting interplays of probability, and the odds, whether for or against, are calculated and implemented incessantly."

Kris Sperry MD [22]

82

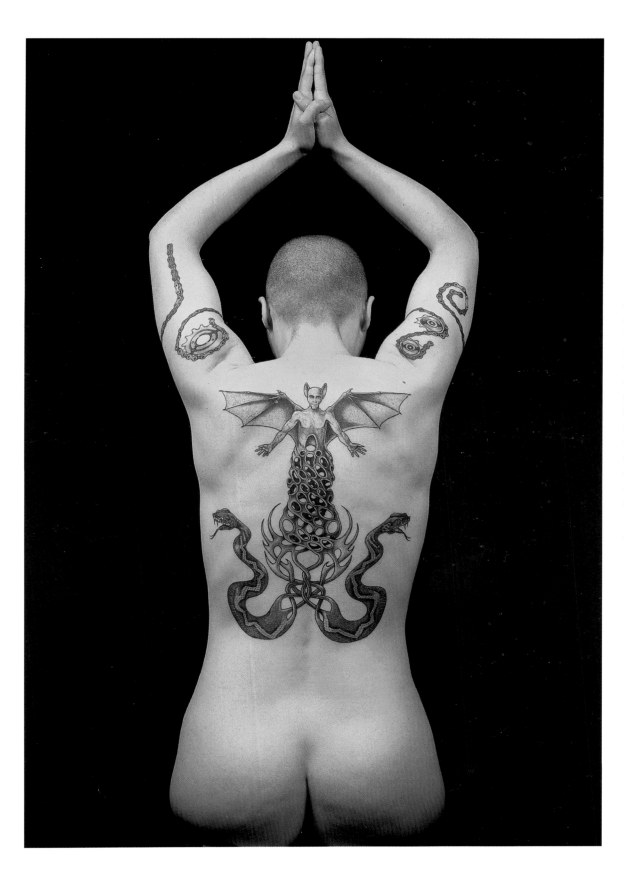

Left: Sunny Maya, tattooed by Preston Wood and photographed in Canada. The central figure of this backpiece is clearly Satan, who is often depicted as having bat's wings in Christian imagery, but the meaning of the snakes is not so straightforward. Depending upon the cultural context, the snake or serpent can symbolize almost anything and everything, from death and destruction to life and resurrection:

It is solar and lunar, life and death, light and darkness, good and evil, wisdom and blind passion, healing and poison, preserver and destroyer, and both physical and spiritual rebirth. It is phallic, the procreative male force it also takes on the feminine characteristics of the secret, enigmatic and intuitional; it is the unpredictable in that it appears and disappears suddenly. (23)

JAN SEEGER

83

myths
and legends

From the earliest days of childhood, our imaginations are stimulated and our view of the world is formed by the myths and legends that are passed on from generation to generation. Even in the technology-obsessed West, it is impossible to conceive of a world without Santa Claus, angels, spirits, ghosts, dragons, leprechauns, mermaids, gorgons, and many more.

Every culture has its own "other world," of monsters and heroes, gods and goddesses, mischievous spirits and unseen forces, providing a wealth of powerful symbolism and vibrant imagery from which we can choose the characters and creatures, places and situations that have special significance for us and that, for whatever reasons, we want to display to others on our skin.

The possibilities for tattoo imagery based on myths and legends are enormous. Some of us prefer to reflect a world of childlike innocence populated by pastel-colored winged horses and playful mermaids, others prefer to associate themselves with the mysterious pagan world of the Green Man, others choose powerful characters from the mythologies of ancient cultures, such as the Greek Gorgon. For tattooed people in the West today, however, the most popular choice by far is the dragon.

This is largely because of the dragon's long association with Japanese tattooing, but there are other reasons too:

The dragon is one of the world's most powerful and widespread symbolic images. Belief in dragon/serpent power is found across ancient cultures as diverse as Babylon, Greece and Mongolia. From water goddesses in serpent form of ancient India and China and the profound spiritual totem of Toltec Mexico – Quetzalcoatl, the feathered serpent – the dragon developed as holy

spirit and bringer of life among many peoples of Europe, Africa and America. It often appeared to mortals in the form of a rainbow.

In more recent Western history dragons took the form of a terrible lizard that evoked the powers of darkness and negativity, something sinister, to be destroyed. But the Oriental dragon represents the awesome pure force of Life itself, a composite creature of magical dimensions that is a study in the balanced negative and positive forces – yin and yang – believed to underlie all existence.

In Asia its breath is charged with fire and water, usually taking the form of spiral clouds that are the manifestation of active cosmic forces The dragon often clutches or is chasing a fiery pearl, variously described as the sun, moon, rolling thunder, or the seed essence of the dual forces of nature. (24)

Thus the dragon is tremendously flexible both in meaning and in the way it is drawn. It can borrow from Japanese or Chinese traditions; it can be fought and beaten by Saint George; it can be a long, legless serpent; it can consist simply of a fire-breathing head; it can be a monster that entwines itself around our entire body and limbs. In so many ways the dragon is the ideal symbol from which to create tattoo masterpieces of infinite variety.

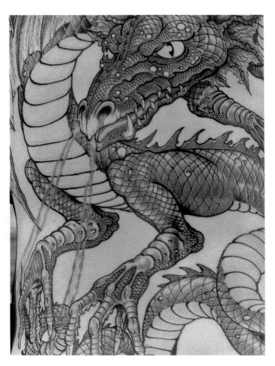

Above: Detail of a dragon back piece on Malin Sonesson of Geneva, Switzerland, by Filip Leu of Switzerland (*see page 87*). Photograph taken in Amsterdam.

JAMES DRURY

Opposite: A glorious Chinese Foo dog. Foo is another name for the Buddha. It is said that the Pekinese dog was bred to imitate this mythical creature, which was half dog and half lion. The design was tattooed on Peer by Greg Orie and photographed in Tennessee.

JAN SEEGER

84

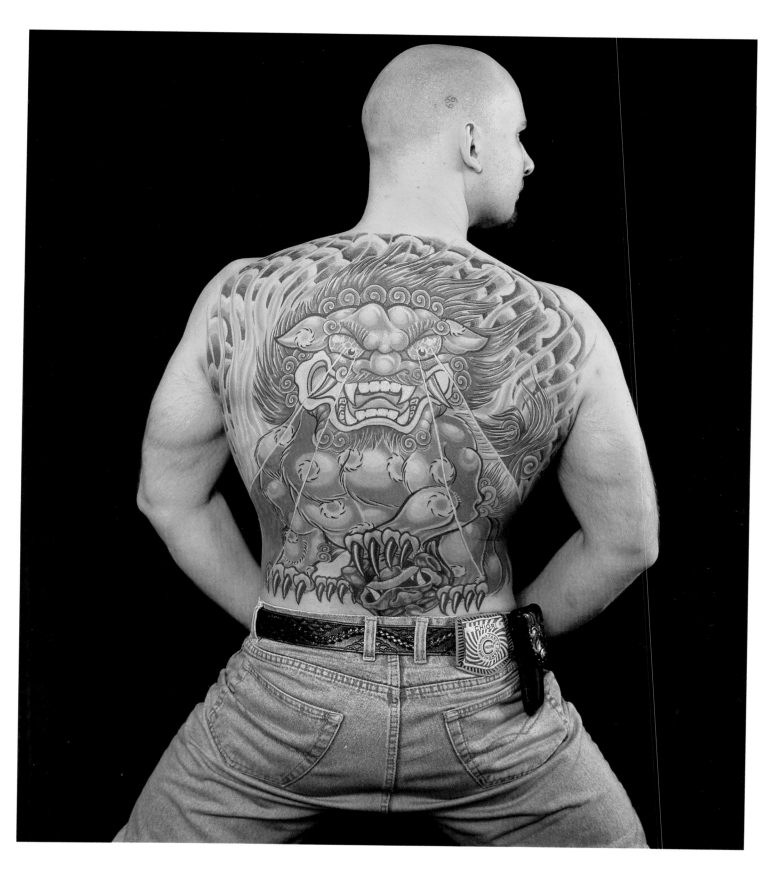

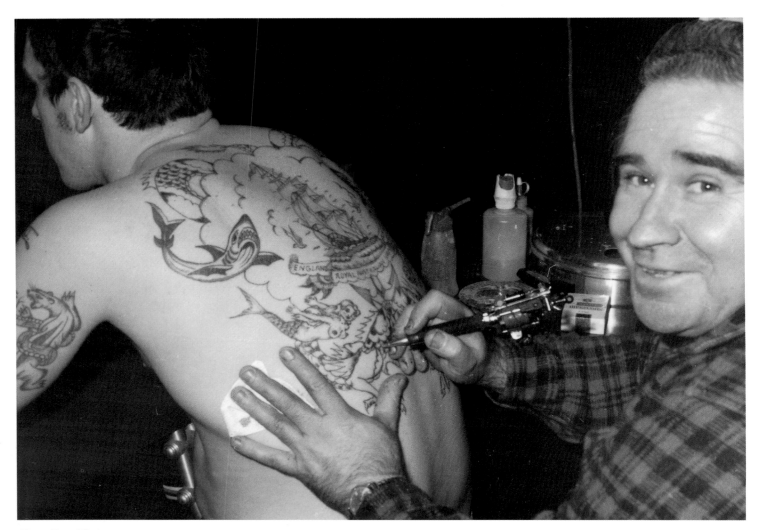

86

Above: Tom of Sydney,
Australia, in the 1970s,
tattooing a back piece
involving ships, sharks,
and mermaids.

THE SKUSE COLLECTION

Right: A three-toed Japanese
dragon by Les Skuse.

THE SKUSE COLLECTION

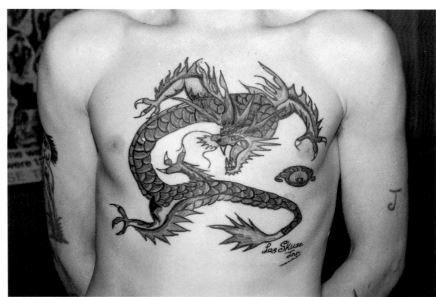

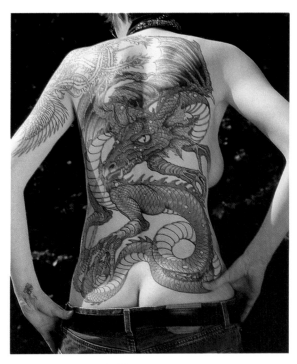

Above: Dragon tattoo by Filip Leu of Switzerland.

The Celtic dragon represents sovereignty. The Red Dragon is the emblem of Wales. Chinese dragons and serpents represent infinity, the supernatural, change, and transformation: the Azure Dragon lives in the sky and is the highest spiritual power. The Imperial Dragon has five claws, its head is to the south and its tail to the north. The hornless dragon lives in the sea and controls the deeps. The common dragon has four claws. The three-clawed dragon was an earlier form which then became the Japanese dragon, which represented both imperial and spiritual power. Two dragons facing each other represent the forces of yin and yang. The pearl that the dragon chases symbolizes spiritual enlightenment.

JAMES DRURY

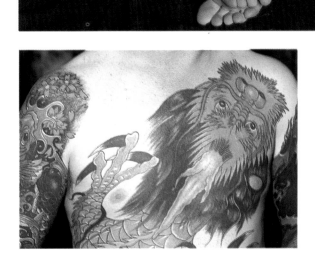

87

Above: Interlocking dragons adorning the waist of Vanessa of Fullerton, California. The tattoo is by Corey Miller.

WILLIAM DEMICHELE

Left: Head of a full-body dragon design tattooed on John Birch by Dennis Cockell.

HENRY FERGUSON

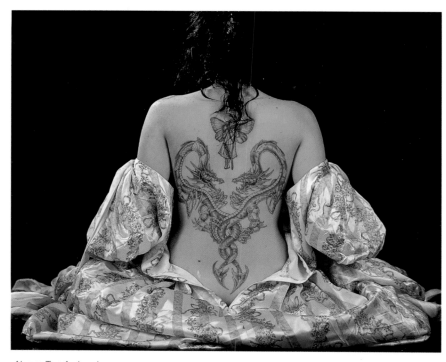

Above: Two facing dragons entwined on the back of Cindy, tattooed by Cory Miller and photographed in California.

JAN SEEGER

Below: A Japanese-style dragon by Ian of Reading, England.

HENRY FERGUSON

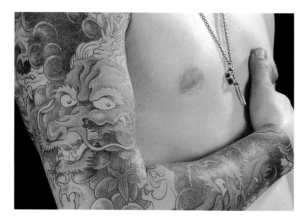

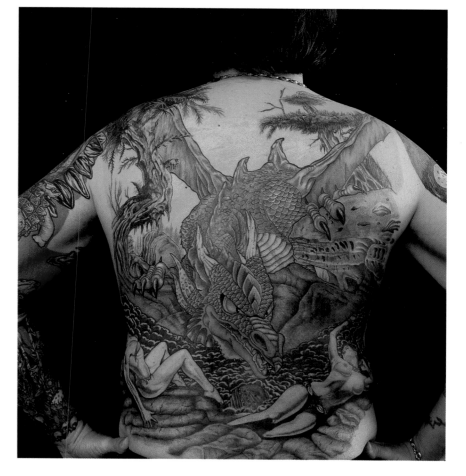

Left: This is the dragon of European myths and legends – a fire-breathing lizard that terrorizes damsels. David's tattoo, by Junebug, was photographed in Tennessee.

JAN SEEGER

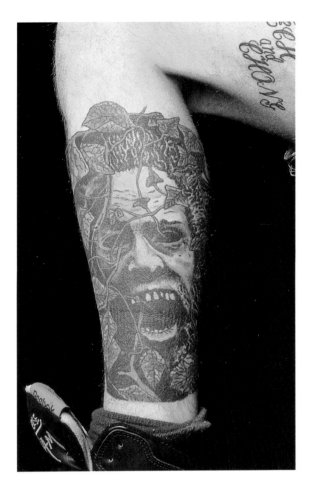

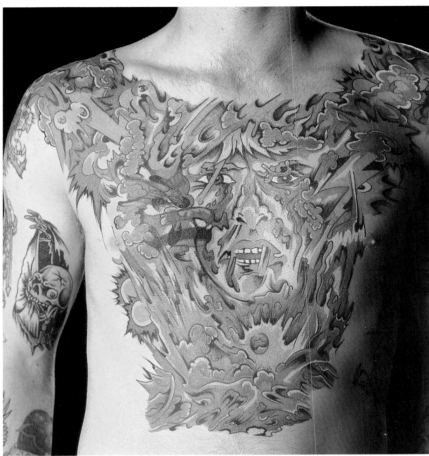

Above: Neil Orange's Green Man. A pagan symbol, the Green Man represented the pre-Christian spirits of nature and the wild woods. The tattoo is by Dave Ayres of Skin Deep Tattooing, Bristol, England.

HENRY FERGUSON

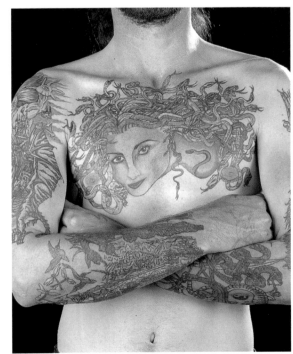

Above: Green Man chest tattoo on John Barry Kelleher of Norfolk, England, by John C. Taylor also of Norfolk, England.

HENRY FERGUSON

Left: An unusually attractive version of the snake-haired Gorgon, Medusa, tattooed on John Williams by Lisa of Art In The Skin.

HENRY FERGUSON

90

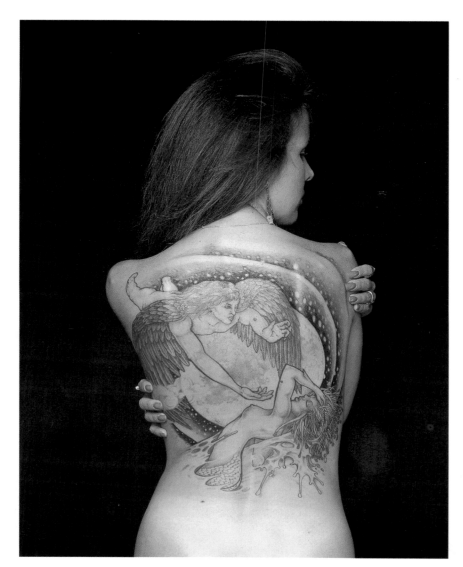

Above: Mythologies also contain many symbols of gentleness, such as this angel and mermaid, tattooed on Jennifer of San Francisco by Shotsie Gorman.

WILLIAM DEMICHELE

Below: Stylized Pegasus tattoo by Paul O'Connor of Weymouth, England. In contemporary Western culture, Pegasus, the winged horse of Greek legend, seems to have developed strong stylistic associations with the virginal white unicorn, a relationship from which it has emerged as a sort of "My Little Pony With Wings."

HENRY FERGUSON

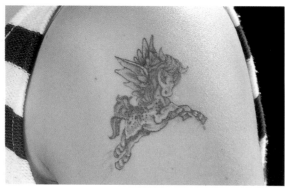

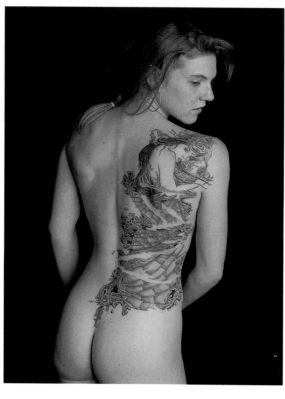

Right: Mermaid adorning the back of Erika of Tucson, Arizona, tattooed by Todd Evans.

WILLIAM DEMICHELE

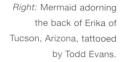

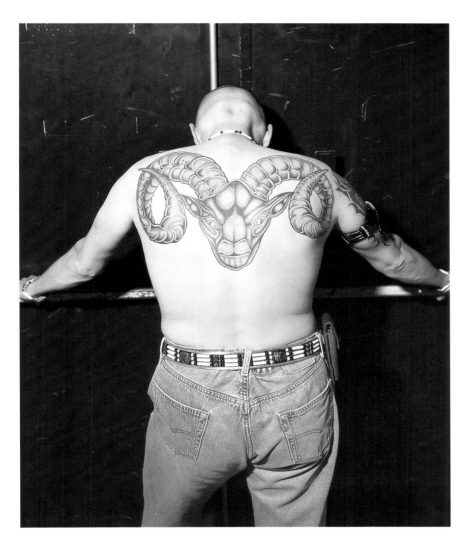

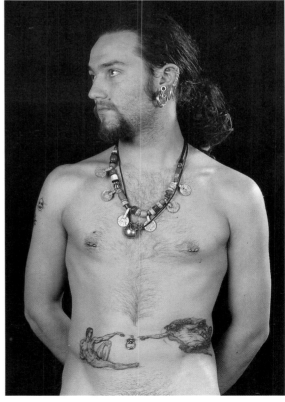

Left: The goat or ram is a symbol of masculinity, virility, and creative force. Tattooed on Nico by Eddy and Tattoo Peter, and photographed in Amsterdam.

JAN SEEGER

Right: Christianity can also provide some powerful images of mythological impact. Here, Michaelangelo's vision of God reaching out to humankind, taken from the ceiling of the Sistine Chapel in the Vatican, Rome, has been tattooed on Fido by Terry Scott.

HENRY FERGUSON

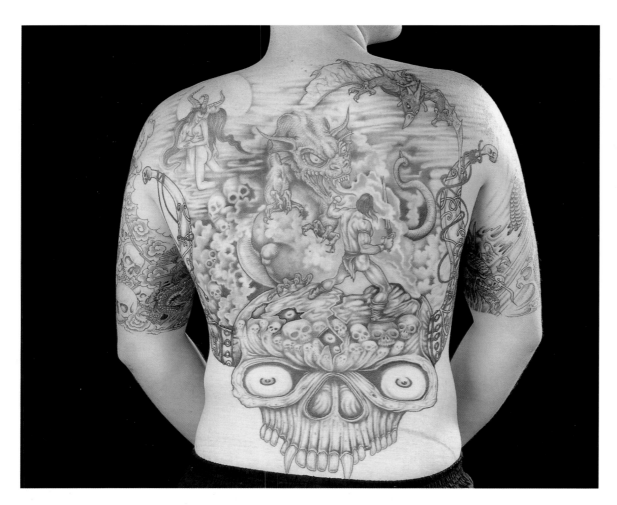

Left: A Conan-like warrior
battles with a fire-breathing
dragon, tattooed by Kevin
Shercliffe on Paul Bentley.

HENRY FERGUSON

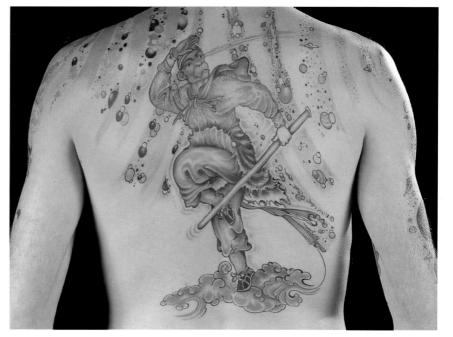

Right: The monkey god of
Chinese legend, tattooed
on Digby Cleaver by
Micky Sharpz.

HENRY FERGUSON

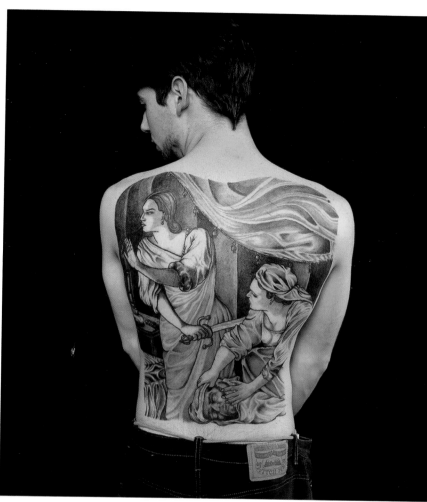

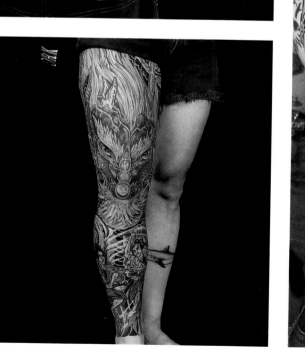

Left: Salome with the head of John the Baptist, tattooed on Stan by Joey Palmer, and photographed in Tennessee.

JAN SEEGER

Below: A Chinese monkey god tattoo photographed in 1983 at a Tattoo Club of Great Britain convention in Weybridge, England.

HENRY FERGUSON

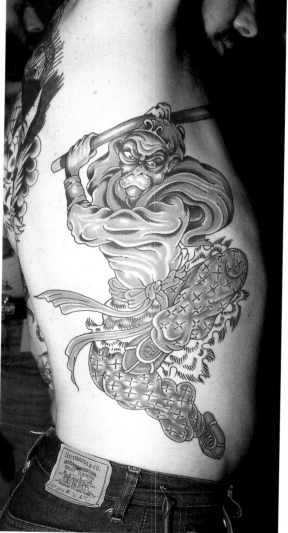

Right: Another version of the pagan Green Man, this time drawn by Larry Davis. Brian, the bearer, was photographed in Canada.

JAN SEEGER

fantasy art

The heroes and heroines, gods and goddesses, mythical beasts and monsters who populate myths and legends are not the only characters to inhabit our imaginations. There are also all the myriad creatures who live in story books and in the lands of magic and fantasy, such as the fairies, elves, witches, wizards, gnomes, goblins, princes and princesses. These beings have a powerful hold over our inner lives which does not stop when we leave childhood behind. It does change, however, over time as we discover new stories and characters, and find new representations of them drawn by artists and illustrators today.

Much of the impetus for the growth of adult fantasy art was provided by artists Boris Valeho and Chris Achilleos. Their ability to visualize – and put down on paper for us to share – vibrantly colorful other worlds, inhabited by glorious creatures totally unlike us, provided a wealth of inspiration for the artists of the tattoo world.

Tattoos were meticulously copied from Valeho's and Achilleos' illustrations, and the exotic sexuality of their creations opened many eyes to the idea that fantasy was not the exclusive preserve of children.

After Valeho and Achilleos, many other artists and illustrators started to excite us and engage our imaginations, and many tattoo artists began to explore their own imaginations and develop their own idiosyncratic fantasy art styles. Some concentrated on eerie blackwork

Right: Warrior-woman fantasy, tattooed on Mark Pedley's upper arm by Saz Saunders.

HENRY FERGUSON

Left: A grisly horned goblin tattooed by Paul O'Connor.

HENRY FERGUSON

scenes of menacing castles atop twisted piles of rocks, others specialized in Merlin-like wizards, or ethereal fairies, or gloriously grotesque goblins. People came to realize that their tattoos could reflect the world of their imagination just as easily as they could show tribal affiliations.

The tattoo artists' customers realized that if they put their bodies into the skilled hands of an expert tattooist, the only limit to the images they could have drawn on their bodies was the limit of their own imaginations. Adult comic-book heroes such as Conan the Barbarian, Red Sonia, and The Silver Surfer made their mark on their flesh. They moved on to the *The X-Files* and discovered the aliens among us. And the endless other possibilities of their fantasies reached out into space and encompassed other worlds, other times, and other universes – where no one has gone before.

Opposite: As this 1940s' photograph of Art, a member of the Bristol Tattoo Club, England, shows, the interest in fantasy art is not new. Here a girl fights with a gorilla while in the background that renowned fantasy hero Tarzan swings to the rescue. Art's tattoos are by the foremost Bristol tattooist of the time, Les Skuse.

THE SKUSE COLLECTION

94

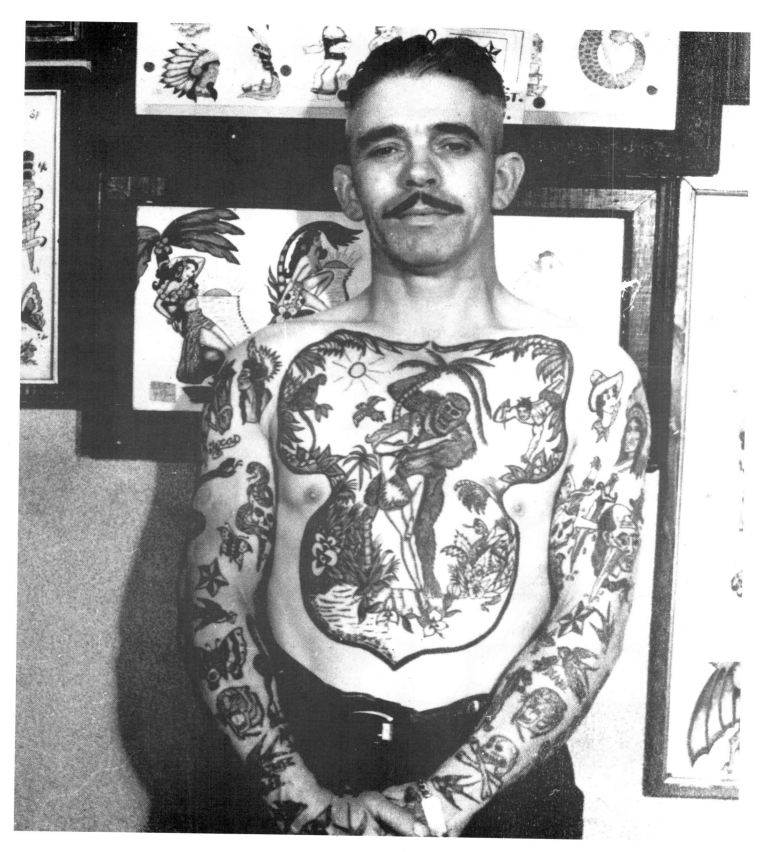

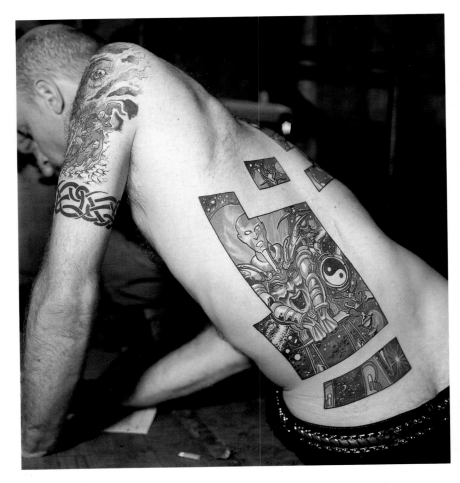

Left: This striking science-fiction image, tattooed on Sarian and photographed in Amsterdam, is made even more exciting by being contained within a series of straight-edged "windows." The tattoos are by Amar and Tin Tin, the eminent French tattoo artist.

JAN SEEGER

Below: The futuristic fetus tattoo by Antoine Muguens on Jean was photographed in Arizona.

JAN SEEGER

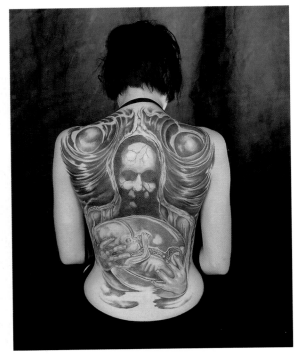

Right: Geometric space-spiral head design, tattooed on Amie of Philadelphia, Pennsylvania, by Don Juan. It is interesting that, although science-fiction stories and images – from Isaac Asimov's robots to the *Starship Enterprise* in its various incarnations – have gripped the imaginations of their countless fans since the 1950s, it is only much more recently that these images have been making a major impact as tattoos.

WILLIAM DEMICHELE

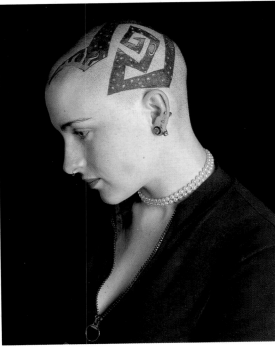

Opposite: In this back piece tattooed on Rodolphie by Manu, and photographed in Arizona, a spaceman is being attacked by an alien monster.

JAN SEEGER

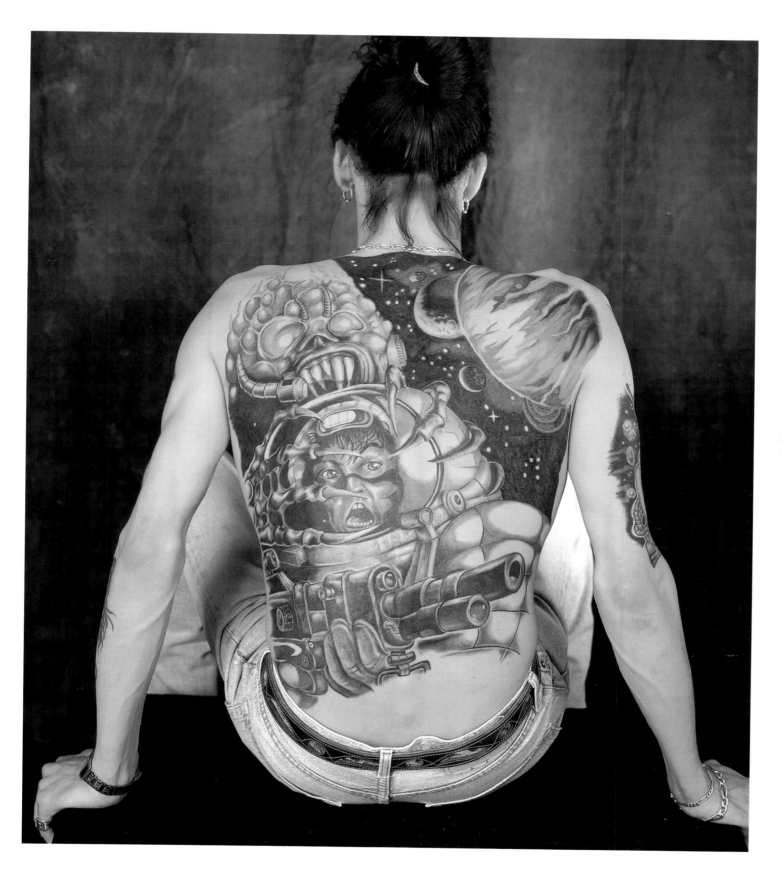

Right: Wizards and unicorn
back piece, tattooed on
Barry Eisenhauer of
Binenweide, Germany,
by Erich of Germany.

HENRY FERGUSON

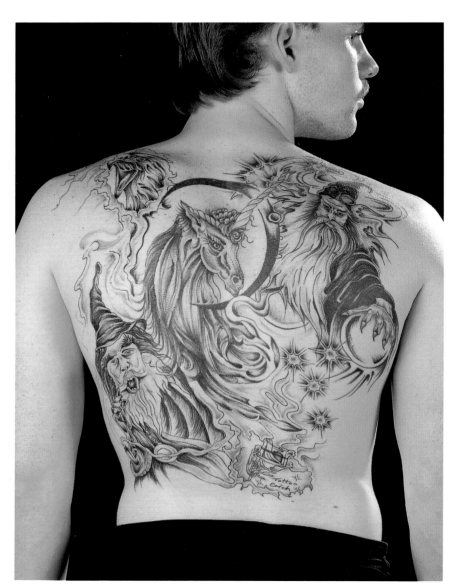

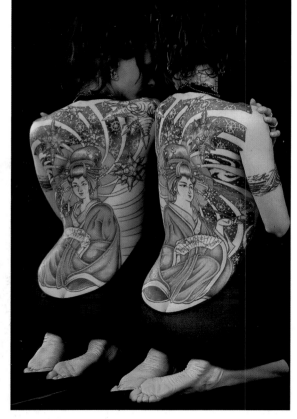

Above: The Japanese
influence meets science-
fiction fantasy: space-geisha
back piece tattooed by Bee
on Debi, and photographed
in Tennessee.

JAN SEEGER

Left: Wizard tattoo on the
back of a girl's shoulder by
Paul O'Connor of Weymouth,
England.

Wizards are very popular
fantasy tattoos with both men
and women.

HENRY FERGUSON

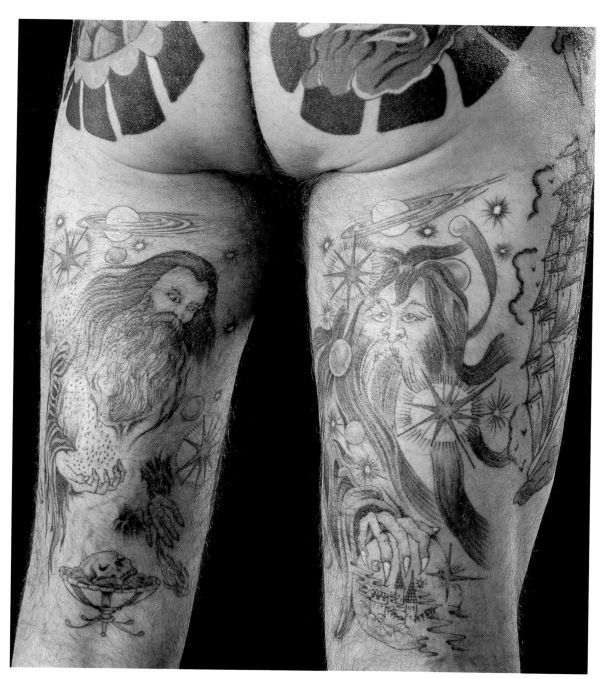

Below: An intertwined winged couple symbolizing, perhaps, both love and innocence. Tattooed by Terry Scott on Rhiannon Easton.

HENRY FERGUSON

Above: Wizards surrounded with orbs and other magical symbols, tattooed on Michael Kickham O'Farrell by Brian Carville.

HENRY FERGUSON

Above and Right: Highly ornate fantasy designs tattooed on Nellie by Julie Moon of New Hampshire:

My body decoration includes a large fantasy piece on my left leg which was done by Julie Moon. I had been planning to have this done for about a year and going to America in '92 for 6 months total, it was the perfect opportunity. This piece is very close to my heart because I had it done at a very good time in my life and parts of it relate to my life then. The whole piece took a lot of thinking about but we put our ideas together and I was pleased with the outcome. (25)

HENRY FERGUSON

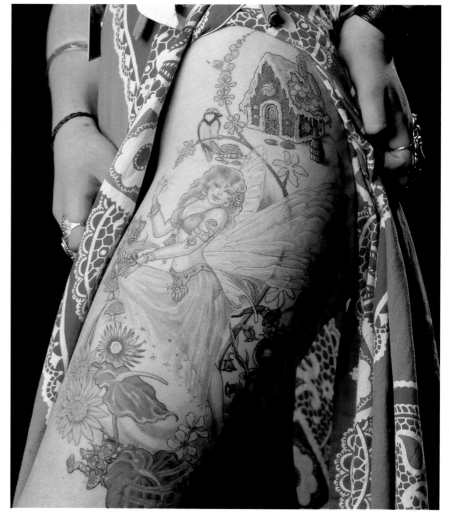

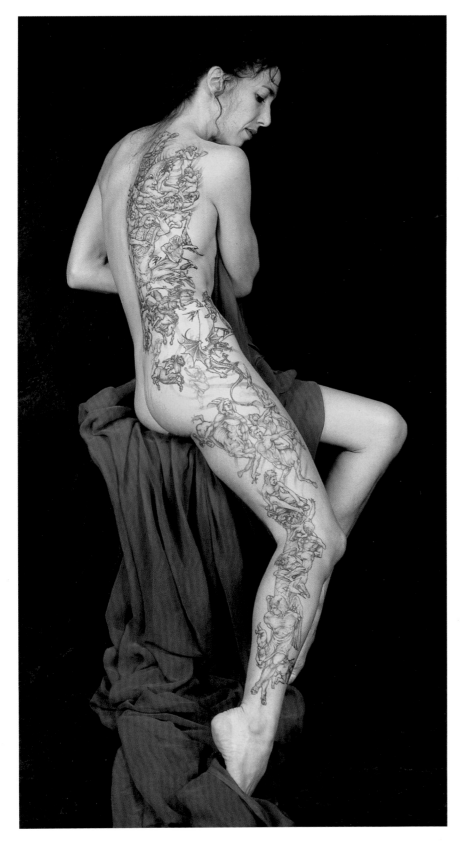

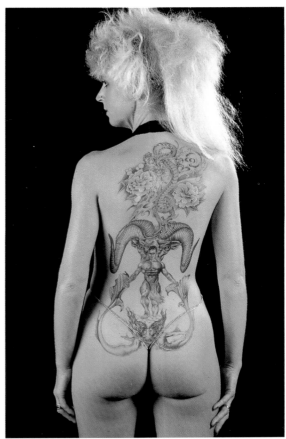

Above: A selection of fantasy figures including the four-toed dragon, a ram's head, muscular hero figure, and a pair of mermaids. Tattooed by Saz Saunders on Tina Isherwood.

HENRY FERGUSON

Left: Full-length fantasy design, tattooed on Carole by Jeff Tulloch, and photographed in Canada.

JAN SEEGER

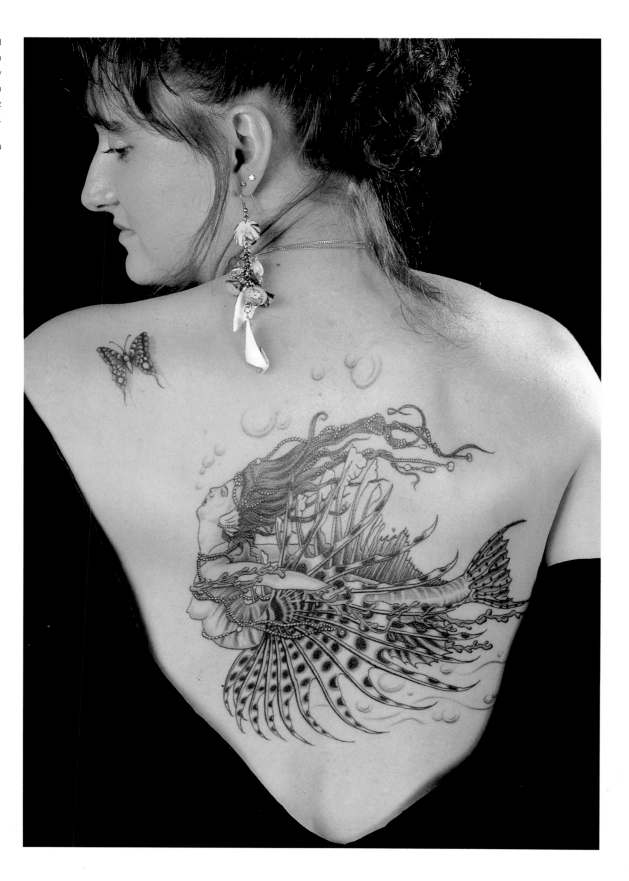

Right: A beautifully executed version of a fish-woman creature, originally created by Chris Achilleos. Tattooed on Claudia Becker by Tattoo Fritz of Landshut, Germany.

HENRY FERGUSON

102

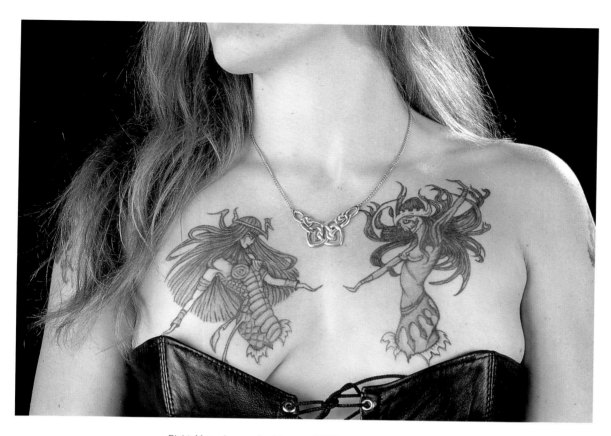

Left: A pair of fantasy sea creatures tattooed on Ness of Brighton, England, by Lisa of Art In The Skin.

HENRY FERGUSON

Right: Monochrome shoulder tattoo of an elf in a tree, tattooed by Micky Sharpz on Tony Shaw of Birmingham.

JAMES DRURY

All the tattoos shown on this page and opposite demonstrate the importance of ensuring that a tattoo is designed to work as well with clothing as without.

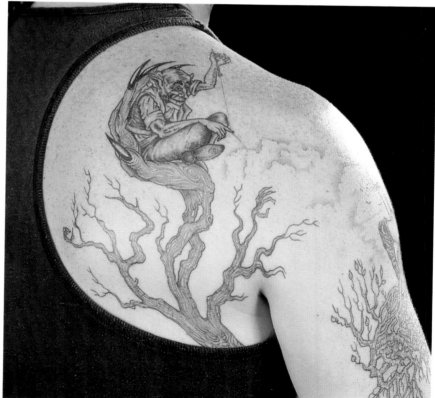

portraits

Whenever we choose to be tattooed with the image of a fantasy hero, or a character from mythology, we do so because that character means something special to us. But for many of us, those specially significant others are not fantasy characters but real people, either those we know personally or those who we know through the movies, television, and music.

Like the images that we choose to wear on our T–shirts or leather jackets, the heroes and heroines who adorn our skin are often selected from the celebrities of stage and screen – such as Marilyn Monroe, Clint Eastwood, Jack Nicholson, and John Wayne – or from the world of rock music. As with being tattooed with the images of our loved ones, it is often wiser to choose the portrait of someone about whom your feelings are unlikely to change. There are numerous stories about men who are tattooed with the names of girlfriends who are then replaced. A similar problem can occur if you choose your tattoo portrait

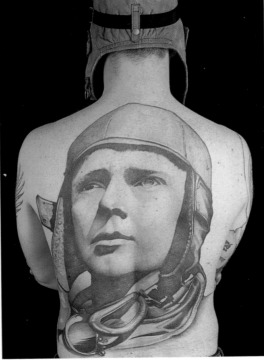

Right: Scotty of Texas sports a heroic portrait of the famous U.S. flyer Lindbergh. Scotty was tattooed by Shotsie Gorman.

JAN SEEGER

heroes unwisely, as was shown when a British soccer fan decided on a major thigh tattoo of his favorite team's star striker – the day after the image was completed the player accepted a transfer to a rival team!

Commemorating dead heroes is generally much safer, as is reflected in the popularity of images of Marilyn Monroe, James Dean, Bob Marley, and other cultural icons, as well as very different heroes of the past such as Winston Churchill, John F. Kennedy, and Martin Luther King.

As tattooists have become more and more adept at "realistic" tattoos that accurately transfer an image such as a portrait onto tattooed skin, some tattoo artists (for example Darren Stares in England) have become particularly well known for their portrait work. Other tattoo artists have taken the idea of the portrait tattoo and expanded it into a wider canvas, using portraits within a scene in the same way that a movie-theater poster artist works, distilling the essential elements to produce a unified tattoo image.

Opposite: Portraits can show a great deal more than the individual's face: this image of the famous director Alfred Hitchcock is surrounded by some of the most memorable scenes from his movies. Benoit's tattoo, by Reynald Mougenout, was photographed in Canada.

JAN SEEGER

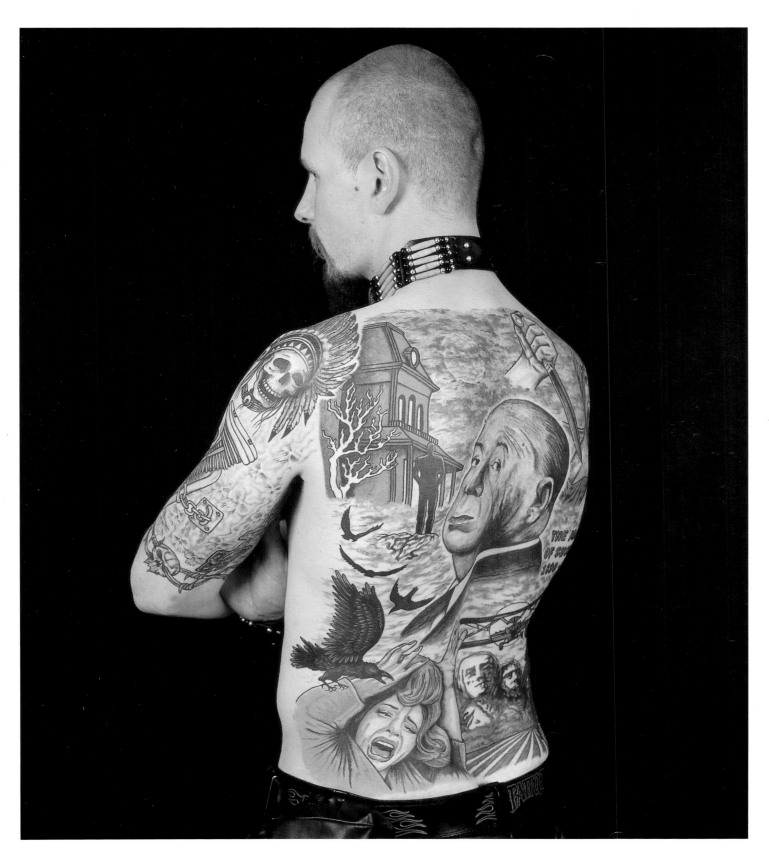

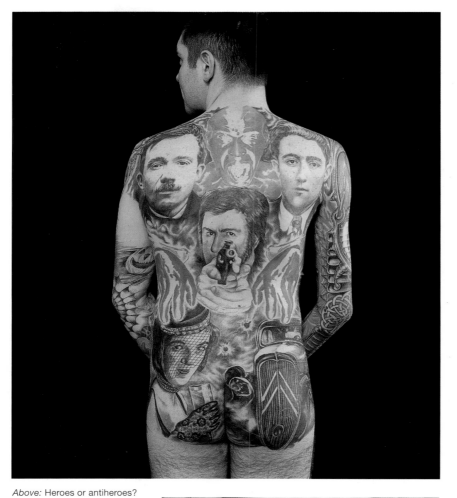

106

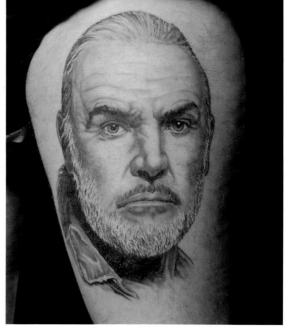

Above: Heroes or antiheroes?
David was tattooed by
Stéphane Chaudesaigues,
and photographed in
Tennessee.

JAN SEEGER

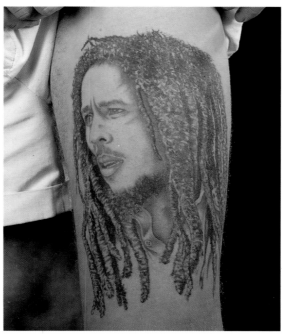

Left: Portrait of Bob Marley by
Darren Stares of Unique
Tattooing, Portsmouth,
England. Stares has
developed a reputation as one
of the very best tattooists of
portraits, receiving many
awards at tattoo conventions
for his work. For example, in
1989 he won the competition
for best "Men's Individual"
tattoo at the Tattoo Expo in
Dunstable, England, with this
portrait, which he tattooed on
his brother Gary's thigh.

HENRY FERGUSON

Above: Portrait of Sean
Connery by Darren Stares
of Unique Tattooing,
Portsmouth, England. In
1992 Stares won both the
"Men's Individual" tattoo
award with this portrait, on
Paul Lashley, and the "Most
Outstanding British Artist,"
at the Tattoo Expo in
Dunstable, England.

HENRY FERGUSON

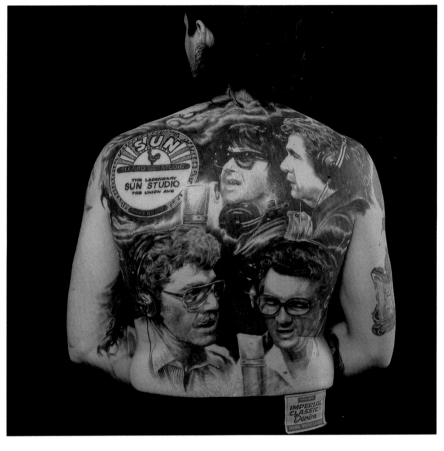

Left: Stéphane Chaudesaigues' recording stars, from the heydays of the famous Sun Studios of Memphis, Tennessee, was tattooed on Alain and photographed in Tennessee.

JAN SEEGER

107

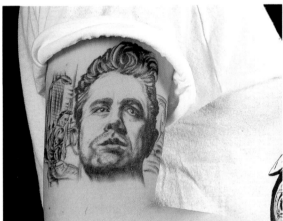

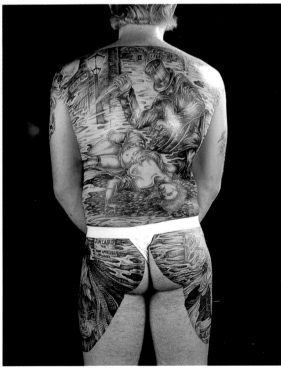

Above: James Dean immortalized in tattoo by Bugsy of Camden, London. In some societies, such as that of Hawaii, it was traditional to be tattooed to commemorate the death of a chief. In other societies, including our own, tattooing has been used to mark the death of a much- loved relative. Today, tattooing is often used to immortalize folk heroes such as Marilyn Monroe, John Wayne, and Buddy Holly.

HENRY FERGUSON

Left: The idea of inking a realistic portrait of an individual into skin has developed in many different directions. The concept is sometimes expanded into a whole scene, such as in this prizewinning Jack The Ripper back piece tattooed on Jim Laird by Ian of Reading, England.

HENRY FERGUSON

flora and fauna

Even with the influx of new styles and influences into the world of tattooing, certain themes have remained consistently popular, particularly images of the natural world. What has changed very much, however, is the way that those images are drawn.

From the very earliest illustrations of Western tattoo designs, animals have provided a wealth of inspiration for tattoo artists. In the main, animal images have always been (and still are) employed as the central subject matter for major tattoos in the center of the chest or back, as for example in the classic theme of an eagle or tiger fighting with a snake. More minor animal images, for example the black panther (which first appeared as a tattoo in the 1930s), have also remained popular subjects for the tattoo artist.

Flowers, such as peonies, cherry blossom, and chrysanthemums, have also been widely portrayed as integral parts within traditional Japanese tattoo designs. Flowers used within Western tattoos generally consisted of simple black-line shapes filled with color; often they were drawn to join up a number of smaller tattoos into one large piece. Some were larger images, meant to stand on their own, but they were still highly stylized. Such larger flower designs were very popular with women customers, and were often advocated as an ideal first tattoo that could later, if desired, be added to in order to create a garland draped across the breasts and shoulders, or down the back.

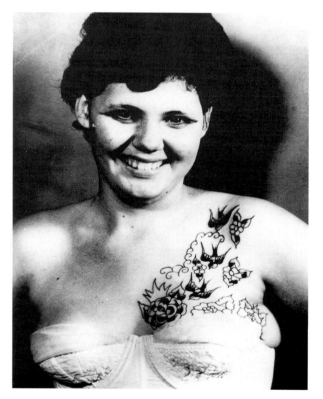

Above: A cheerful woman from the early 1960s adorned with a swag of traditional-style bluebirds and flowers.

THE SKUSE COLLECTION

Today, tattoos of flora and fauna are, if anything, more popular than ever, but the range of subjects and the variety of execution have changed beyond recognition. We can choose between exquisite seascapes of colorful tropical fish, tribal-style blackwork lizards, beautifully detailed butterflies, floral garlands like medieval book illustrations, pastel showers of petals, simple, graphic irises and lotuses, voluptuous roses, simple leaping dolphins, and menacing octopuses wrapping their tentacles around every limb. The choice is breathtaking.

But if it was necessary to choose one animal, or family of animals, that is more popular than any other, it is quite clearly the cat family that most appeals to people. From sweet little fluffy kittens chasing butterflies, to prides of lions relaxing on the savannah, to fierce tigers ripping their way through human flesh, the cat is still for so many the supreme symbol with which to adorn the body. Perhaps this is because the cat epitomizes the extremes of human nature – on one hand representing warm, domestic values; on the other, the power and amorality of the jungle.

Opposite: Fierce animals locked in mortal combat were popular themes for tattoos in the early twentieth century. The classic version is the Battle Royal between an eagle and a serpent, but there were many variations, such as this one by Les Skuse, including combinations of eagles, snakes, dragons, and tigers.

THE SKUSE COLLECTION

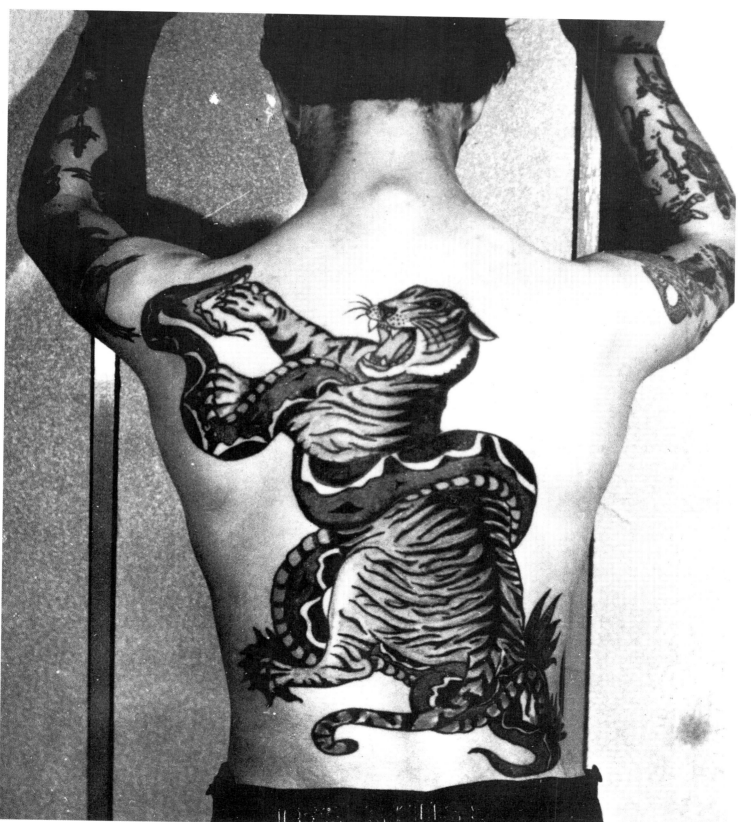

109

Below: Carla's beautifully realistic flowers were tattooed by Trevor Marshall and photographed in California. Compared to the traditional flowers shown on page 108, today's designs have become much more varied, and styles of execution range from the super-realistic to the highly stylized, but flowers of every sort continue to inspire tattoo artists and their customers, particularly women.

JAN SEEGER

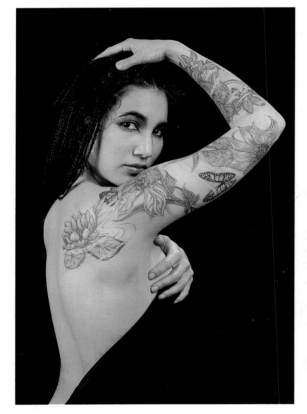

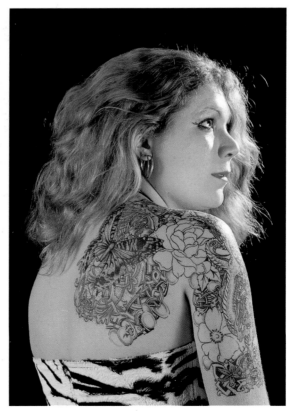

Above: Flower design, delicate in execution and position, performed on Annalee of Castleton, New York, by Pete Mahr. This is a good example of how a tattoo design does not have to be large or complicated to make a strong impact.

WILLIAM DEMICHELE

Right: A shoulder piece depicting a butterfly surrounded by flowers, and executed in the pointillist style on Liselle by Brent of Dunstable, England.

HENRY FERGUSON

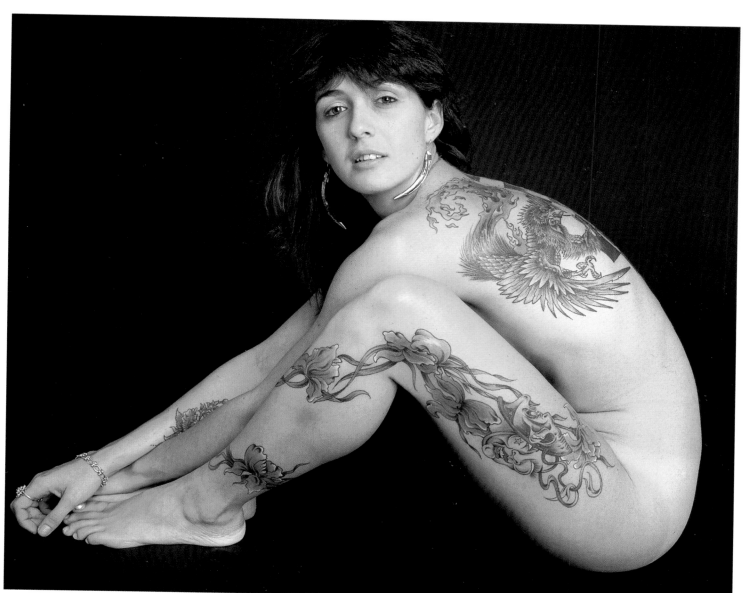

Above: Lynn of Scottdale, Georgia. All Lynn's tattoos, including the beautiful irises on her leg, are by "Painless" Paul Nelson.

WILLIAM DEMICHELE

"Perhaps one of the more remarkable aspects of our times is that many of the supposedly primitive aspects of human behaviour, like tattooing, body piercing, scarification and 'tribal' types of hairstyles have spread widely throughout very different age groups of the population in our high-tech Western world. In fact, as the technology of our world becomes more antiseptic, coldly clinical and impersonal in appearance, the old hidden magic – the marriage of sensuality, physical sensation and mental exhilaration – has returned to take over more and more of us." Dick Taylor (26)

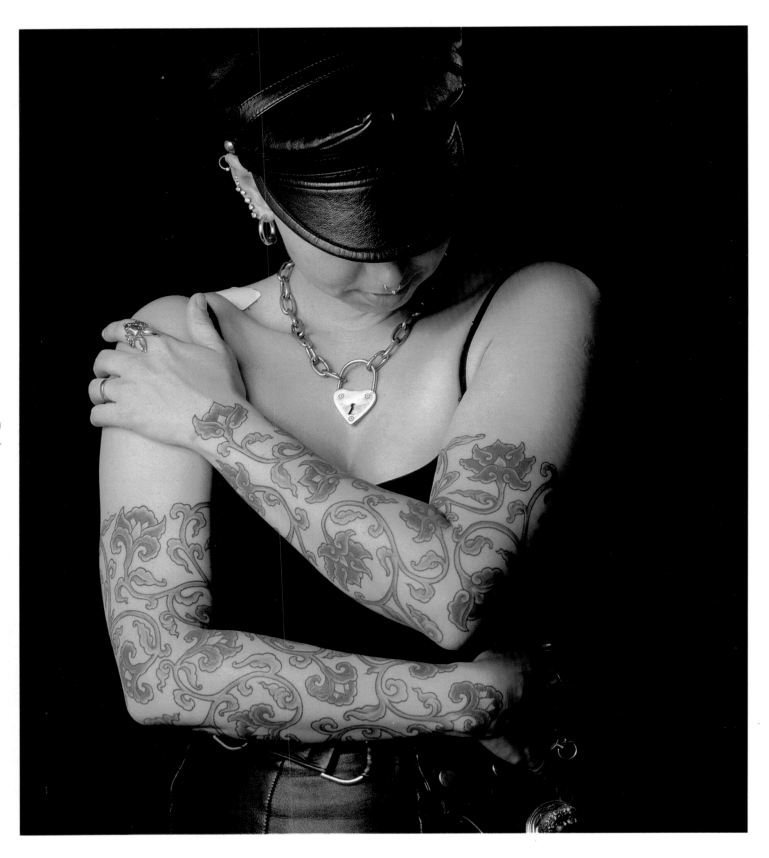

112

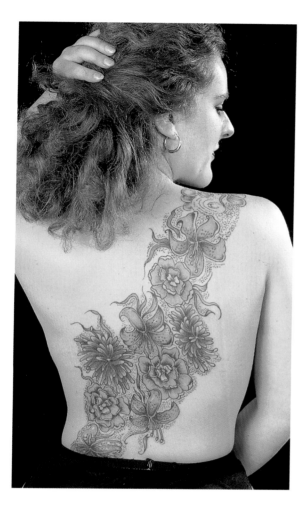

Left: This floral design tattooed on Martina Ruhstarfe of Hanover, Germany, by Erich of Germany is part of a garland that extends over her shoulder and diagonally down her back.

HENRY FERGUSON

Below: Floral tattoos executed in a super-realistic style can be as effective as the stylized designs, as for example in this back piece of beautifully observed roses of all colors. Tattooed on Rose A. Starr of Manchester, London, by Louis Molloy.

HENRY FERGUSON

113

Opposite: The highly stylized design, tattooed on Elayne Binnie by Alex Binnie, is based upon the classic flower and leaf motifs that appear in innumerable examples of the decorative arts throughout history. They are seen on the floral borders used to illustrate copies of the Koran in the twelfth century, on medieval European illuminated manuscripts, and are incorporated into the late nineteenth-century art and craft designs of William Morris, which are still being used on fabrics and wallpapers today.

HENRY FERGUSON

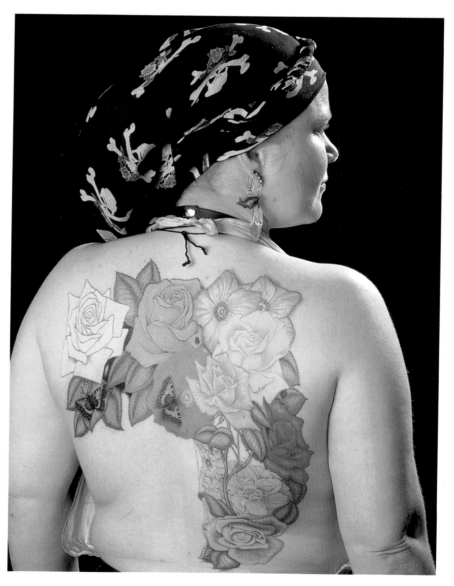

114

Above: Lisa Bland and Martha Shaw of Gloucestershire, England, revealing their designs tattooed by Bob Moore of Cheltenham.

HENRY FERGUSON

Lisa: I just love tattoos, I think they're brilliant. Most people think that when you walk into a tattooist's it's all anchors and love hearts and scrolls with Mum and Dad written in them, but it's not, it's amazing pieces of art really, every one of them.

Martha: Yes, definitely! I've always wanted one . . .

Lisa: But she never had the guts.

Martha: It's not that, it's just that they were always little roses and little red devils – so common – but when he showed me this one it struck me that, yes, this was the thing to have done Something different, you can't have anything common these days. Everyone's got them, haven't they? (27)

Below: Different images of cats can produce very different responses in the onlooker: the playful kittens that Natalie Smart had tattooed by Terry Scott on her thights carry a very different message from the images of wild and dangerous big cats that many tattooed people choose.

HENRY FERGUSON

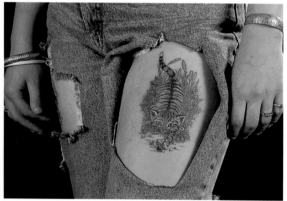

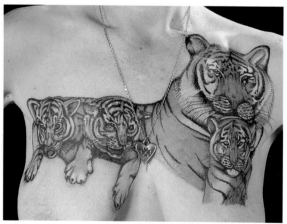

Above: Tiger by Paul O'Connor on Bobby Salter of Manchester, England: Bobby Salter came in one day, looked at the walls and said: "I want a proper tiger, not one of those"; so she started bringing in her own pictures. The first one was on her backside, then she sort of got addicted to them – chest, shoulder blade, upper arm. (28)

HENRY FERGUSON

Right: Big-cat shoulder pieces on Paul Bennett of Surrey, England, executed by Terry Scott. Cat designs have become Terry Scott's specialty (*see also below right*).

HENRY FERGUSON

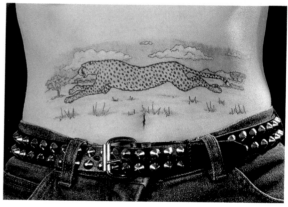

115

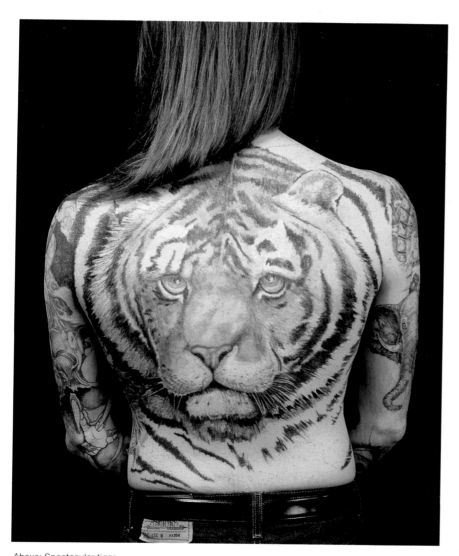

Above: Spectacular tiger back piece in the realistic style by Kerry Miller, enlivening James' back. James was photographed in California.

JAN SEEGER

Above: Terry Scott of Reigate, England, displays her own Cheetah design. Terry Scott is one of the new breed of tattoo artists – young, female and an artist who works on skin as well as in other media: I've been painting since I was about three and trying to earn a living at it since I left school. I got into tattooing by accident: I had a tattoo done. My tattooist was selling all his equipment and I decided to have a go I didn't think I'd enjoy it at all, but I did. It was the best thing I ever did. It was just a bit of luck really. I was desperate to earn some money one way or another. I thought 'Well, it's almost art, I'll have a go.' I didn't think I could actually do art-work, I thought it was going to be 'tattoos.' It took me about a year before I discovered I could do anything I liked As regards subjects, I've always painted and drawn animals, mainly cats, and they're very popular. (29)

HENRY FERGUSON

116

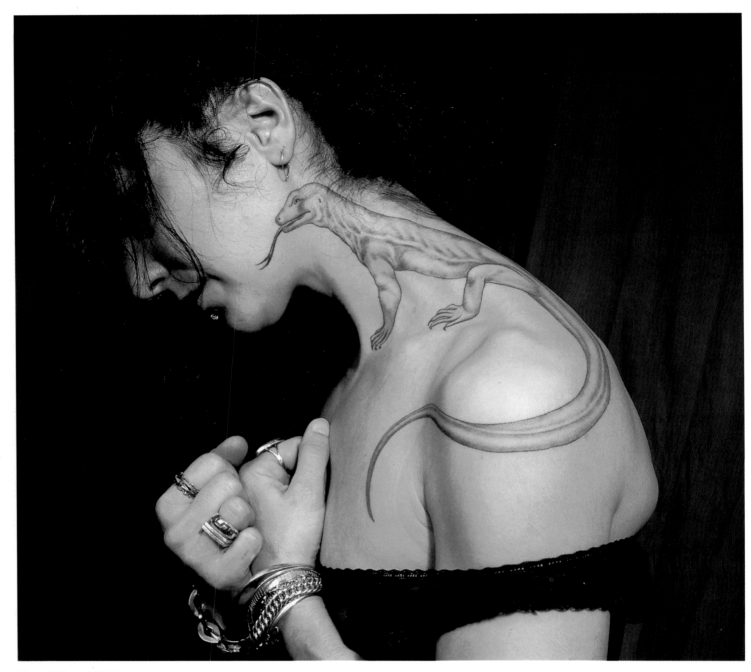

Above: Tattoo by Juli Moon on Delphine. Tattoos of animals can be incredibly versatile, and often have an emotional impact that is difficult to quantify. Delphine was photographed in Maine.

JAN SEEGER

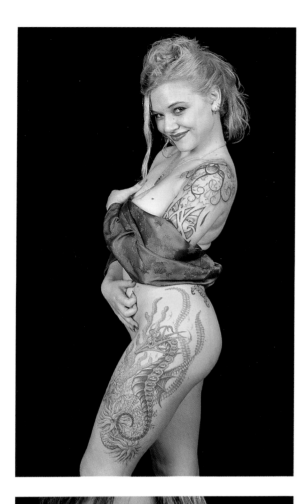

Left: Sea horses, such as this example tattooed on Jennifer by Victor Whitmil and photographed in California, convey a combination of beauty, fragility, and mystery.

JAN SEEGER

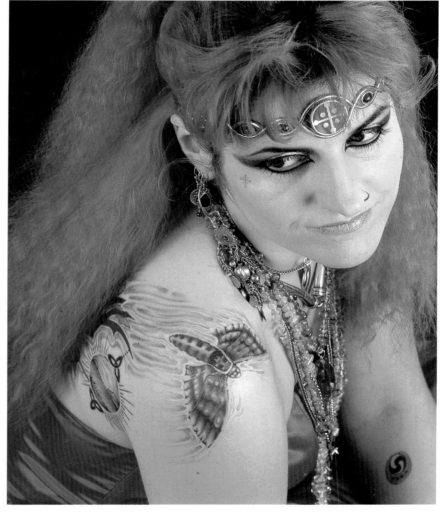

117

Left: This spider tattoo on Angelique Zucconi by Bugsy of Camden, London, seems to be deliberately and challengingly unpretty and unfeminine.

JAMES DRURY

Above: A moth tattoo on Joolz, representing the freedom of the spirit. All tattoos by Micky Sharpz.

HENRY FERGUSON

abstract art

The impact on established Western tattooing of all the waves of new styles and influences has been enormous. New ideas and possibilities have crashed down upon us, shaking the very foundations of our assumptions about what tattooing is and can be.

In the past, tattooing was generally considered, by the tattooists themselves as much as by the public at large, to be a craft and not an art. Tattooists served apprenticeships with other tattoo artists, and learned how to use the tools of the trade and how to reproduce designs that were often copied from other tattooists. Although many of these men and women knew that they were highly skilled, they would have derided the suggestion that they were in fact real artists.

But certain of the long-established tattooists have been brave enough to acknowledge the art in what they do, and in the work other tattooists have done before them. Don Ed Hardy, in particular, has waged a ceaseless battle for tattooing to be accepted as the vibrant and creative art form that it is.

The resurgence in popularity of tattooing today has brought into the business a new breed of tattooists (some of whom have had art-school training) who love art, who know about cubism and surrealism and the work of artists such as Miro and Picasso, and who are not afraid to stand up in public and state that they are not just tattooists but also artists.

Freed from the constraints of tattoo traditions by the constant need to re-evaluate this most powerful of art forms, we are finding it possible to move beyond "pictures of things" and beyond the ideas and traditions of other cultures, be they Japanese, Maori, Samoan, Tahitian, or whatever, to create a new kind of tattooing – a tattooing that has no need to "be" anything other than what it is. And if asked, "But what is it? What does it mean?," the only answer is simply, "It's a tattoo."

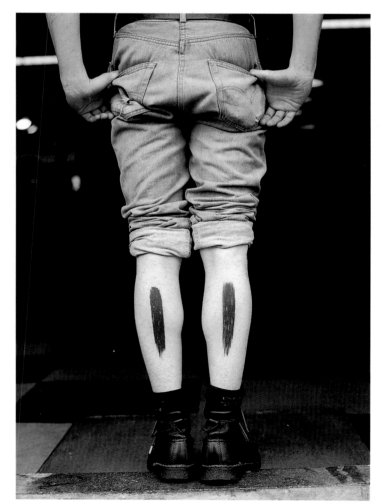

Right: Darko, photographed in Holland. Right-leg tattoo by Greg Orie, left-leg tattoo by Jimmy Hendrix.

JAN SEEGER

118

Opposite: Peter and Margaret Keelan from County Durham, England. Her abstract shoulder tattoo is by Alex Binnie. His Borneo-inspired shoulder tattoo is by Northside Tattooz of Whitley Bay, England.

HENRY FERGUSON

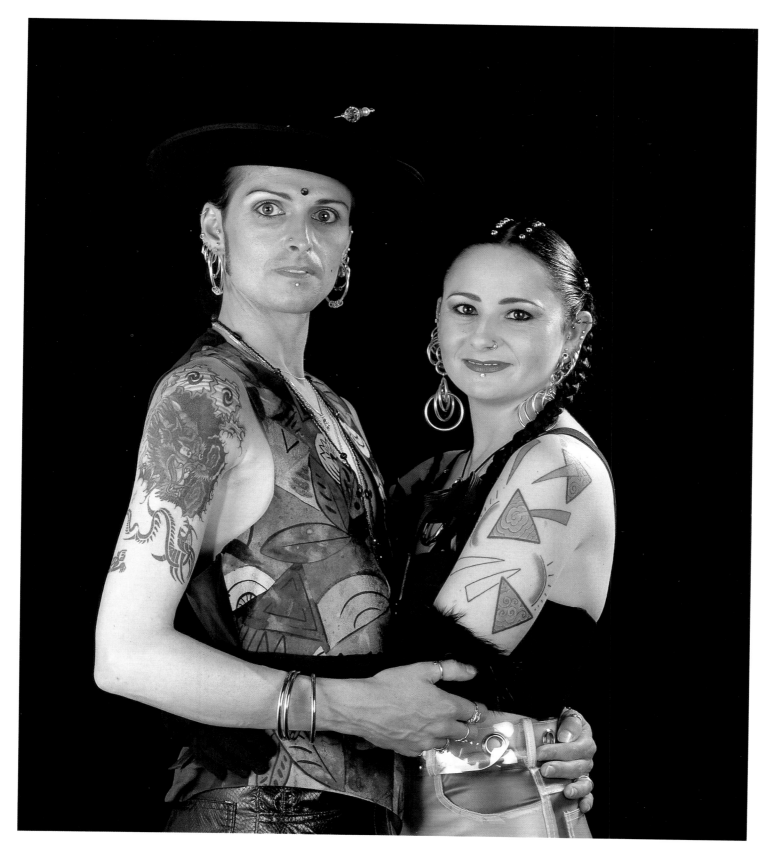

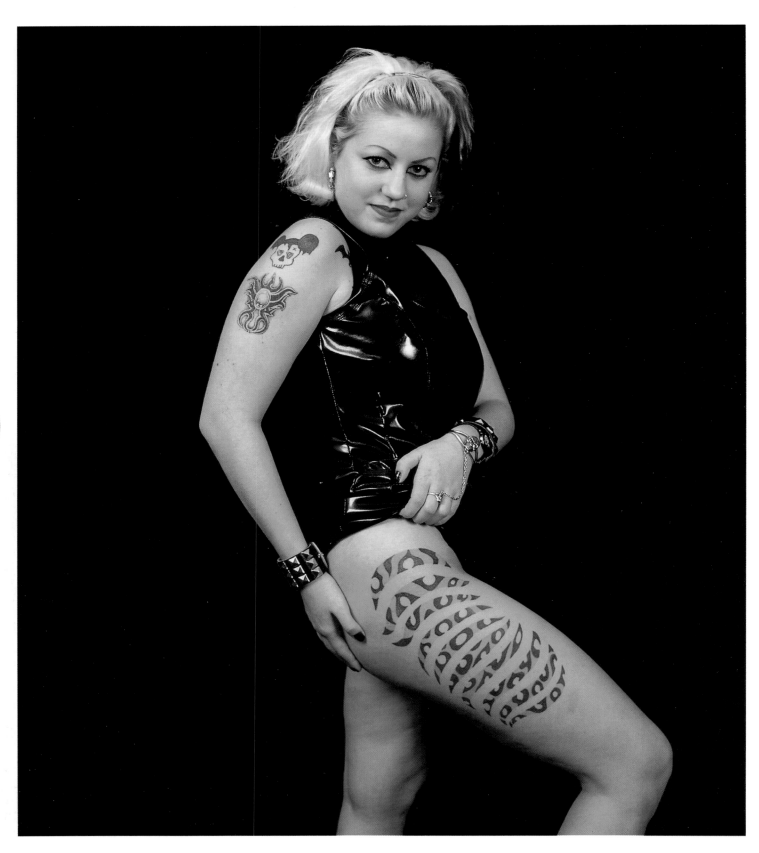

Left: This exciting version of a Jackson Pollock painting by Kari Barba shows why she is at the forefront of new-style tattooing. Michelle was photographed in California.

JAN SEEGER

Below: A "tribal corset" design, which uses the motifs of traditional blackwork to produce a very modern effect. Wendy was tattooed by Trevor Marshall, and photographed in California.

JAN SEEGER

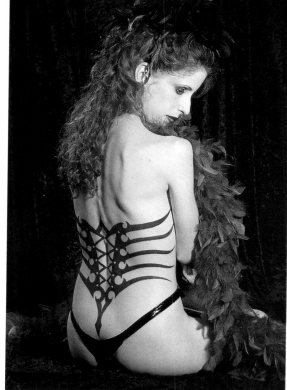

Opposite: Lisa's pattern of leopard-like spots, photographed in Canada, is transformed into an intriguing abstract design in this thigh tattoo by Bob Paulin (other tattoos by Justin Woodstanley).

JAN SEEGER

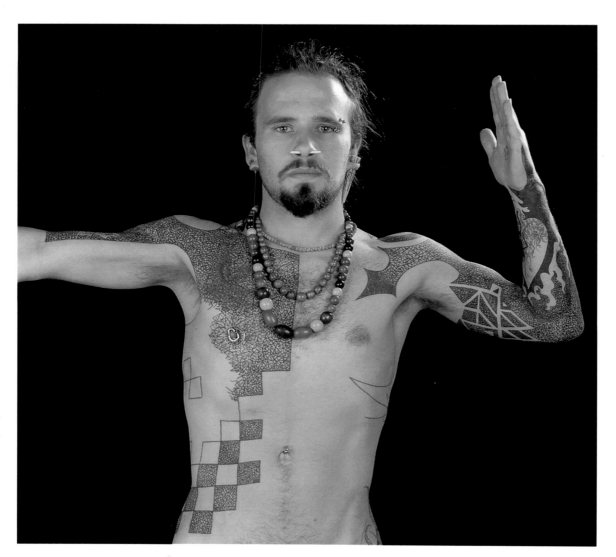

Left: Xed Le Head sporting his selection of abstract designs tattooed by himself, Alex Binnie, and Andy Short. Tattooing today attracts a new kind of customer who is interested not just in collecting tattoos but in transforming him – or herself into their own unique creation.

HENRY FERGUSON

"The very deviance of the tattoo – its perversity – has exerted an influence on conventional society. It may not be proper to admit to an attraction to tattoos – much less to consider having one – but it would appear that there is more interest in the subject than conventional morality would like to admit."

Donald McCallum (30)

Right: David's ornate "sleeves" of wing and scroll designs were tattooed by Alex Binnie, and photographed in Tennessee.

JAN SEEGER

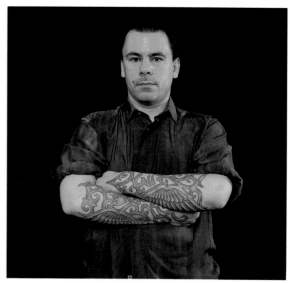

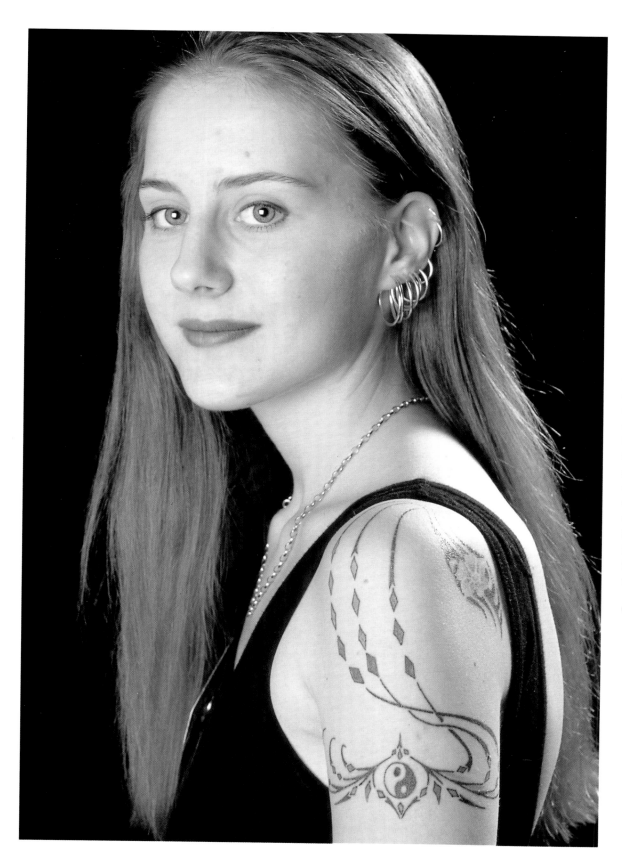

Left: Lisa of Bromley, England, displaying a delicate shoulder piece by Lisa of Art In The Skin. This is a perfect example of what Don Ed Hardy was referring to when he wrote:

The evolution of "tattoo boutiques" and a widening of the practice from marginalized sectors into society at large has taken a toll on the raw spirit of the old underground art Many older-generation tattooers still working resent the current shift in designs and techniques that has made their business more difficult. Competition is far more intense and the growing numbers of tattooers makes it harder to earn a competent living, despite the greater number of people getting tattooed. For most, the expansion of the art has meant saying goodbye to the good old days. The five hundred or so professional tattooers operating in the United States in the 1960s has increased by about ten thousand as of this writing. (31)

HENRY FERGUSON

123

Below: Another beautifully executed abstract design by Kari Barba. This thigh piece on Michelle looks toward the future, not to the past, and clearly owes much more to the Museum of Modern Art than to any other influence.

JAN SEEGER

124

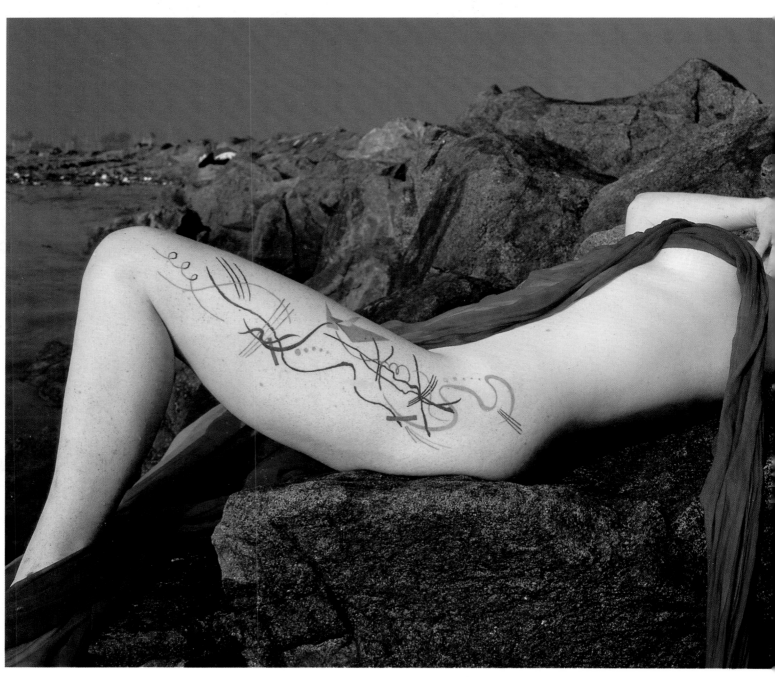

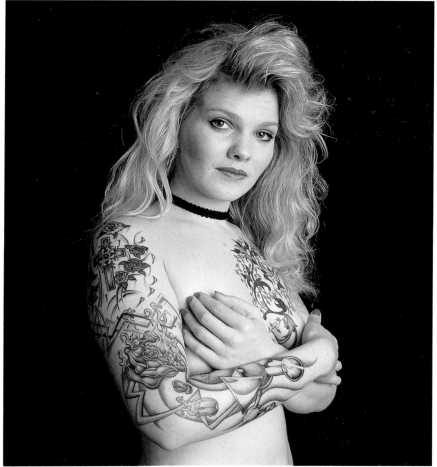

125

Above: Justine of Rochester, New York, bares her right-arm sleeve tattoo by Tom S. Herman and her chest tattoo by Joe T. The effect of the enormous range of very different styles that have influenced tattooing over recent years has been to release tattooists from the discipline of being expected to work in just one style, freeing them to take tattooing wherever they wish – mixing, for example, traditional images, such as the Cross and bleeding heart, with airbrush-style shading, abstract art, geometrical shapes and colors beyond the wildest dreams of the tattooists of the past.

WILLIAM DEMICHELE

references

HISTORY of TATTOOING

1. Polhemus, Ted, and Housk Randall. *The Customized Body*. Serpent's Tail, London, 1996, p. 7.

2. Scutt, R. W. G., and C. Gotch. *Art, Sex and Symbol*. Cornwall Books, Cranbury, NJ, 1974 & 1986, p. 21.

3. Going, Chris. "Scythian Man." *body art*, Issue 1, 1987, p. 27.

4. Bianchi, Robert S. "Tattoo in Ancient Egypt." Edited by Arnold Rubin. *Marks of Civilization*. University of California, Los Angeles, 1988, pp. 21-23.

5. Bianchi, Robert S. "Tattoo in Ancient Egypt." Edited by Arnold Rubin. *Marks of Civilization*. University of California, Los Angeles, 1988, p. 28.

6. Berchon, E. *Histoire Médicale du Tatouage*. Paris, 1869. Quoted in: Scutt, R. W. G., and C. Gotch. *Art, Sex and Symbol*. Cornwall Books, Cranbury, NJ, 1974 & 1986, p. 26.

7. Richie, Donald, and Ian Buruma. *The Japanese Tattoo*. Weatherhill, New York & Tokyo, 1980, 1989, 1991, p. 26.

8. Te Awekotuku, Ngahuia. "Maori: People and Culture." *Maori: Art and Culture*, British Museum Press, London, 1996, pp. 41-42.

9. Peter, Hanns. "Marks of Prestige, Mourning and Obligation." Edited by Karl Groning. *Decorated Skin: A World Survey of Body Art*. Thames and Hudson, London, 1997, p. 94.

10. Kaeppler, Adrienne. "Hawaiian Tattoo: A Conjunction of Genealogy and Aesthetics." Edited by Arnold Rubin. *Marks of Civilization*. University of California, Los Angeles, 1988, p. 168 169.

11. Kaeppler, Adrienne. "Hawaiian Tattoo: A Conjunction of Genealogy and Aesthetics." Edited by Arnold Rubin. *Marks of Civilization*. University of California, Los Angeles, 1988, p. 169.

12. Wroblewski, Chris. *Skin Shows IV*. Virgin, London, 1995, p. 110.

13. Teilhet-Fisk, Jehanne. "The Spiritual Significance of Newar Tattoos." Edited by Arnold Rubin. *Marks of Civilization*. University of California, Los Angeles, 1988, p. 139.

14. Rubin, Arnold. "Native America." Edited by Arnold Rubin. *Marks of Civilization*. University of California, Los Angeles, 1988, p. 179.

15. & 16. Coleman, Tim. "The Last Picture Show." *body art*, Issue 19, 1993, p. 33.

17. Bulwer Lytton, E. G. *Harold, the Last of the Saxon Kings*. G. J. Howell, London, 1848 &1907, p. 522.

18. Scutt, R. W. G., and C. Gotch. *Art, Sex and Symbol*. Cornwall Books, Cranbury, NJ, 1974 & 1986, p. 27, quoting W. Lithgow. *The Totall discourse of the rare adventures and painefull perigrinations of William Lithgow 1632*. Glasgow, 1906, p. 253.

19. Scutt, R. W. G., and C. Gotch. *Art, Sex and Symbol*. Cornwall Books, Cranbury, NJ, 1974 & 1986, p. 27.

20. Scutt, R. W. G., and C. Gotch. *Art, Sex and Symbol*. Cornwall Books, Cranbury, NJ, 1974 & 1986, p. 165, quoting G. Burchett. *Memoirs of a Tattooist*. Pan Books, London, 1960, p.48.

21. Scutt, R. W. G., and C. Gotch. *Art, Sex and Symbol*. Cornwall Books, Cranbury, NJ, 1974 & 1986, p. 89.

22. Scutt, R. W. G., and C. Gotch. *Art, Sex and Symbol*. Cornwall Books, Cranbury, NJ, 1974 & 1986, p. 90.

23. Webb, Doc. "Sailors 'n Tattoos." Edited by D.E. Hardy. *Tattootime No.3: Music & Sea Tattoos*. Hardy Marks Publications, Honolulu, 1988, p. 10.

24. Scutt, R. W. G., and C. Gotch. *Art, Sex and Symbol*. Cornwall Books, Cranbury, NJ, 1974 & 1986, p. 152.

25. Gilbert, Steve. "Totally Tattooed: Self-Made Freaks of the Circus and Sideshow." Edited by Randy Johnson, Jim Secreto, and Teddy Varndell. *Freaks, Geeks & Strange Girls*. Hardy Marks Publications, Honolulu, 1996, p. 102.

26. Parry, A. *Tattoo: Secrets of a Strange Art as Practised by the Natives of the United States*. Simon & Schuster, New York, 1933, pp. 60-63.

27. Scutt, R. W. G., and C. Gotch. *Art, Sex and Symbol*. Cornwall Books, Cranbury, NJ, 1974 & 1986, p. 154.

28. Hardy, Don Ed. "The Name Game." *Tattootime No. 1: New Tribalism*. Hardy Marks Publications, Honolulu, 1982 & 1988, p. 51.

29. Hardy, Don Ed. "Tattooing as a Medium." *Pierced Hearts and True Love: A Century of Drawings for Tattoos*. The Drawing Center, New York, and Hardy Marks Publications, Honolulu, 1995, p.16.

30. Hardy, Don Ed. "Tattooing as a Medium." *Pierced Hearts and True Love: A Century of Drawings for Tattoos*. The Drawing Center, New York, and Hardy Marks Publications, Honolulu, 1995, p.19.

STYLES and INFLUENCES

1. From an interview with Suzi. *body art*, Issue 1, 1987, p. 27.

2. Fellman, Sandi. *The Japanese Tattoo*, Abbeville Press, New York, 1986, p. 43.

3. Richie, Donald, and Ian Buruma. *The Japanese Tattoo*. Weatherhill, New York & Tokyo, 1980, 1989 & 1991, p. 89.

4. Hardy, Don Ed. "In Japanese Waters." *Tattootime No.3: Music & Sea Tattoos*, Hardy Marks Publications, Honolulu, 1988, p. 48.

5. Hardy, Don Ed. *Tattootime No. 1: New Tribalism*. Hardy Marks Publications, Honolulu, 1988.

6. Binnie, Alex. "Binnie: Pop Tribal." *body art*, Issue 15, 1991, p. 28.

7. Raven, Cliff. "Thoughts on Pre-Technological Tattooing." Edited by D.E. Hardy. *Tattootime No.1: New Tribalism*. Hardy Marks Publications, Honolulu, 1982 & 1988, p. 11.

8. Binnie, Alex. "Reducer." *body art*, Issue 13, 1991, p. 28.

9. Taylor, M. C. *Pierced Hearts and True Love: A Century of Drawings for Tattoos*. The Drawing Center, New York, and Hardy Marks Publications, Honolulu, 1995, p. 39.

10. Dave Nelson interviewed by Marcus Podilchuk, *body art*, Issue 6, 1989, pp. 9-10.

11. Anton, Ferdinand. "Ancient America: Art for Gods, Men and Spirits." Edited by Karl Groning. *Decorated Skin: A World Survey of Body Art*. Thames and Hudson, London, 1997, p. 27.

12. Gallagher, Karl. "Painted Britons." *body art*, Issue 20, 1994, p. 34.

13. Gallagher, Karl. "Painted Britons." *body art*, Issue 20, 1994, p. 31.

14. & 15. Micky "Sharpz" Lewis interviewed by Marcus Podilchuk. *body art*, Issue 6, 1989, p. 14.

16. Binnie, Alex. "Binnie: Pop Tribal." *body art*, Issue 15, 1991, p. 28.

17. Schefold, Reimar. "Mentawai: Beauty is the Soul's Delight." Edited by Karl Groning. *Decorated Skin: A World Survey of Body Art*. Thames and Hudson, London, 1997, p. 195.

18. Taylor, M. C. "Skinscapes." *Pierced Hearts and True Love: A Century of Drawings for Tattoos*. The Drawing Center, New York, and Hardy Marks Publications, Honolulu, 1995, p. 39.

19. Halley, Hamish. *body art*, Issue 20, 1994, pp 21-22.

20. Sperry, Kris. "A Pathologist's Perspective." Edited by D. E. Hardy. *Tattootime Vol.4: Life & Death Tattoos*. Hardy Marks Publications, Honolulu, 1987, p. 71.

21. Peters, Megan J. "Expo '91 Revisited." *body art*, Issue 17, 1992, p.21.

22. Sperry, Kris. "A Pathologist's Perspective." Edited by D. E. Hardy. *Tattootime Vol.4: Life & Death Tattoos*. Hardy Marks Publications, Honolulu, 1987, p. 70.

23. Cooper, J. C. *An Illustrated Encyclopedia of Traditional Symbols*. Thames and Hudson, London, 1978 & 1995, pp. 146-147.

24. Hardy, D. E. "The Dragon" *Tattootime No.2: Tattoo Magic*. Hardy Marks Publications, Honolulu, 1988. page 30-31.

25. Nellie. *body art*, Issue 20, 1994, p.18.

26. Taylor, Dick. "Mind, Body and Soul." *body art*, Issue 1, 1987, p. 39.

27. Lisa Bland & Martha Shaw interviewed by Lynn Procter. *body art*, Issue 9, 1990, p.22.

28. Paul O'Connor interviewed by Marcus Podilchuk. *body art*, Issue 7, 1989, p.28.

29. Terry Scott interviewed by Lynn Procter. *body art*, Issue 8, 1989, pp. 24-26.

30. McCallum, Donald. "Historical and Cultural Dimensions to the Tattoo in Japan." Edited by Arnold Rubin. *Marks of Civilization*. University of California, Los Angeles, 1988, p. 133.

31. Hardy, Don Ed. "Tattooing as a Medium."*Pierced Hearts and True Love: A Century of Drawings for Tattoos*. The Drawing Center, New York, and Hardy Marks Publications, Honolulu, 1995, p.22.

credits

Tim Coleman: A television, radio and print journalist, Tim has lived in London, Egypt and (currently) California. He has traveled widely, developing a particular interest in tattooing and other forms of body decoration.

William DeMichele: New-York-State based tattoo enthusiast and photographer, specializing in portraits of tattooed women. Bill travels widely, including visits to numerous tattoo conventions, and has been published in many tattoo magazines as well as in his own book *The Illustrated Woman*.

James Drury: A photographer and designer based in Colchester, England, James worked for Henry Ferguson on *body art* magazine for several years.

Henry Ferguson: As a British professional photographer specializing in architectural photography and body decoration, Henry became frustrated by the lack of suitable outlets for his tattoo photography and created *body art* magazine. Since the first issue was published in 1987 he has been *body art*'s editor, publisher, and major photographer.

Dick Parsons: Freelance photographer based in Clacton-on-Sea, England, specializing in documenting local characters and lifestyle.

Jan Seeger: The world's foremost female tattoo photographer, Jan was originally from the East Coast of the United States, but is now based in Los Angeles. She regularly travels to many parts of the world (especially New Zealand) to photograph tattooing, and her pictures have appeared in several books as well as in all the top tattoo magazines.

Chris Wroblewski: A pioneer in the field of tattoo photography, Chris has been taking, exhibiting, and publishing photographs of tattoos since the late 1970s. His was some of the very first published work showing the best and newest tattooing, and his single-minded devotion to taking photographs of ground-breaking tattoo work has been of importance in the acceptance of tattooing as an art form. He has had numerous books of tattoo photography published and today moves between bases in London, France, and Germany, spending much of his time traveling the world in order to photograph traditional tattooing. Chris publishes his pictures through his own Skin Shows imprint.

The Skuse Collection: In the 1950s and 1960s Les Skuse of Bristol was one of Britain's top tattoo artists. He was extremely interested in discovering more about and promoting tattooing, he ran the Bristol Tattoo Club (one of the biggest at that time), and he exchanged letters and photographs with other tattoo artists and enthusiasts around the world. His son Bill also became a tattooist, as did Bill's wife Rusty, who became internationally famous in the early 1970s as the World's Most Tattooed Lady. Bill also continued exchanging and selling tattoo photographs, and on his death items from his collection were snapped up by fans, tattooists, and tattoo museums worldwide.

further reading

body art magazine. Publications Limited, Norfolk, England.

Bonge, Steve. *Tattoo'd With Attitude*. Virgin Books, London, 1995.

Cooper, J. C. *An Illustrated Encyclopedia of Traditional Symbols*. Thames and Hudson, London, 1978 & 1995.

Delio, Michelle. Tattoo: *The Exotic Art of Skin Decoration*. Virgin Books, London, 1994.

DeMichele, William. *The Illustrated Woman*. Proteus Press, New York, 1992.

The Drawing Center. *Pierced Hearts and True Love: A Century of Drawings for Tattoos*. The Drawing Center, New York and Hardy Marks Publications, Honolulu, 1995.

Fellman, Sandi. *The Japanese Tattoo*. Abbeville Press, New York, 1986.

Groning, Karl. *Decorated Skin: A World Survey of Body Art*. Thames and Hudson, London, 1997.

Hardy, D. E. and the Ann Nathan Gallery. *Eye Tattooed America*. Hardy Marks Publications, Honolulu, 1993.

Hardy, D. E. *Forever Yes: Art of the New Tattoo*. Bryce Bannatyne/Hardy Marks Publications, Honolulu, 1992.

Hardy, D. E., ed. *Sailor Jerry Collins: American Tattoo Master*. Hardy Marks Publications, Honolulu, 1994.

Hardy, D. E., ed. *Tattootime No.1: New Tribalism*. Hardy Marks Publications, Honolulu, 1982 & 1988.

Hardy, D. E., ed. *Tattootime No.2: Tattoo Magic*. Hardy Marks Publications, Honolulu, 1988.

Hardy, D. E., ed. *Tattootime No.3: Music & Sea Tattoos*. Hardy Marks Publications, Honolulu, 1988.

Hardy, D. E., ed. *Tattootime Vol.4: Life & Death Tattoos.* Hardy Marks Publications, Honolulu, 1987.

Hardy, D. E., ed. *Tattootime Vol.5: Art From The Heart*. Hardy Marks Publications, Honolulu, 1991.

Jaguer, Jeff. *The Tattoo: A Pictorial History*. Milestone Publications, Horndean, England, 1990.

Johnson, Randy, Jim Secreto and Teddy Varndell, eds. *Freaks, Geeks & Strange Girls*. Hardy Marks Publications, Honolulu, 1996.

Lautman, Victoria. *The New Tattoo*. Abbeville Press, New York, 1994.

Meehan, Aidan. *Celtic Design: A Beginners Manual (1991); Knotwork (1991); Animal Patterns (1992); Illuminated Letters (1992); Spiral Patterns (1993); Maze Patterns (1993); The Dragon and The Griffin (1995); The Tree of Life (1995)*. Thames and Hudson, London.

Meehan, Bernard. *The Book of Kells: An illustrated introduction to the manuscript in Trinity College Dublin*. Thames and Hudson, London, 1994.

Nicholas, Anne. *The Art of the New Zealand Tattoo*. Citadel Press, New York, 1994.

Paul Rogers Tattoo Research Center.

Flash from the Past: Classic American Tattoo Designs 1890-1965. Hardy Marks Publications, Honolulu, 1994.

Polhemus, Ted, and Housk Randall. *The Customized Body*. Serpent's Tail, London, 1996.

Richie, Donald, and Ian Buruma. *The Japanese Tattoo*. Weatherhill, New York & Tokyo, 1980, 1989, 1991.

Rubin, Arnold, ed. *Marks of Civilization*. University of California, Los Angeles, 1988.

Schiffmacher, Henk. *1000 Tattoos*. Taschen, Cologne, 1996.

Scutt, R. W. G., and C. Gotch. *Art, Sex and Symbol*. Cornwall Books, Cranbury, NJ, 1974 & 1986.

Starzecka, D.C. ed. *Maori: Art and Culture*. British Museum Press, London, 1996.

Stead, Ian, and Karen Hughes. *Early Celtic Design*. Thames and Hudson, London, 1997.

Vale, V., and Andrea Juno, eds. *Re/Search #12: Modern Primitives*. Re/Search Publications, San Francisco, 1989.

Wilson, Eva. *8000 Years of Ornament: An illustrated handbook of motifs*. British Museum Press, London, 1994.

Wilson, Eva. *North American Indian Designs*. British Museum Press, London, 1984.

Wojcik, Daniel. *Punk And Neo-Tribal Body Art*. University Press of Mississippi, Jackson, 1995.

Wroblewski, Chris. *Classic Skin Shows*. Spaulding Rogers, New York, 1995.

Wroblewski, Chris. *Skin Shows I: The Art of Tattoo*. Virgin Books, London, 1989.

Wroblewski, Chris. *Skin Shows II: The Art of Tattoo*. Virgin Books, London, 1991.

Wroblewski, Chris. *Skin Shows III: The Art of Tattoo*. Virgin Books, London, 1993.

Wroblewski, Chris. *Skin Shows IV*. Virgin Books, London, 1995.

Wroblewski, Chris, and Heide Heim. *Skin Shows V*. Chris Wroblewski Skin Shows Publishing, London, 1997.

Wroblewski, Chris. *Tattooed Women*. Virgin Books, London, 1992.

Wroblewski, Chris. *Tattooed Women Two*. Skin Shows Publishing, London, 1994.

127

authors' acknowledgments

The authors would like to thank:
Christopher Gotch, Don Ed Hardy, Donald Richie, and all those whose printed works have
provided so much valuable and fascinating information: all our photographic contributors
(especially Jan Seeger for her unfailing enthusiasm, encouragement and sense of humour during
all our late-night transatlantic telephone calls); Paul Sayce for his assistance in checking the text
and captions for factual errors, for his general support, and for being an all-round nice guy; and
our editors Will Steeds and Roz Cocks for their enthusiasm and faith in this project.

Thanks also to all the tattooed people and tattoo artists whose work appears in this book –
without you none of this would have been possible. We hope that your appearance in
this book will give you as much pleasure as we know it will give others.

body art magazine

More about body art magazine....
The Art of the Tattoo has been produced in association with body art magazine.
Copies of the magazine are available from:
Publications Limited, PO Box 32, Great Yarmouth, Norfolk, NR29 5RD, England.

Photograph on page 8:
Traditional Samoan Pai (or Pe'a),
tattooed by Pio Faaofontuu. Steve was
photographed in New Zealand.

Photograph on page 28:
Juliette of Massachusetts
with neotraditional tattoos
by Marcus Pacheo.

BOTH PHOTOGRAPHS BY JAN SEEGER